Wonders
of the Pyramids

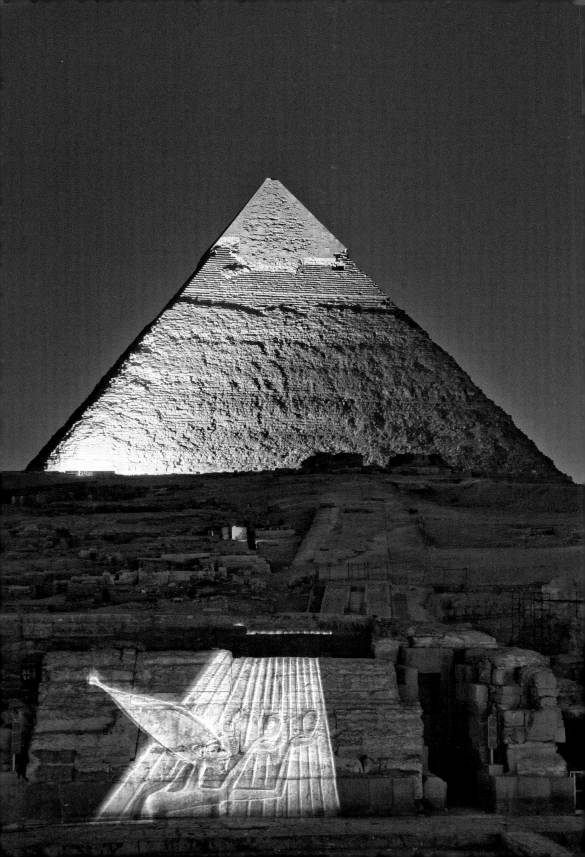

Wonders
of the Pyramids

The Sound and Light of Giza

Introduced by

Zahi Hawass

Misr Company for Sound, Light, & Cinema—Cairo
Distributed by the American University in Cairo Press

Copyright © 2010 by
Misr Company for Sound, Light, & Cinema
Abu-l-Hol Square, Nazlet al-Semman, Pyramids, Giza
www.soundandlight.com.eg

Photographs by Emad Allam, pages ii, 8–9, 13, 14, 34–35, 58–72, 89
Photograph by Sherif Sonbol, pages 36-37

Dar el Kutub No. 23255/09
ISBN 978 977 17 8027 4

Dar el Kutub Cataloging-in-Publication Data

Hawass, Zahi
 Wonders of the Pyramids: The Sound and Light of Giza/ Introduced by Zahi Hawass. First
 edition.—Cairo: The American University in Cairo Press, 2010

 90 p. cm.
 ISBN 978 977 17 8027 4
 1. Theater–sound effects 2. Pyramids–Egypt
 I. Hawass, Zahi, 1947 (intro)
 792.024

1 2 3 4 5 6 7 8 15 14 13 12 11 10

Distributed by the American University in Cairo Press
113 Sharia Kasr el Aini, Cairo, Egypt
420 Fifth Avenue, New York, NY 10018
www.aucpress.com

Designed by Adam el Sehemy
Printed in Egypt

Contents

Preface 1
 Essam Abdel Hadi

The Magic of the Pyramids of Giza 3
 Zahi Hawass

The Pyramids Sound and Light Show 71

Suggestions for Further Reading 88

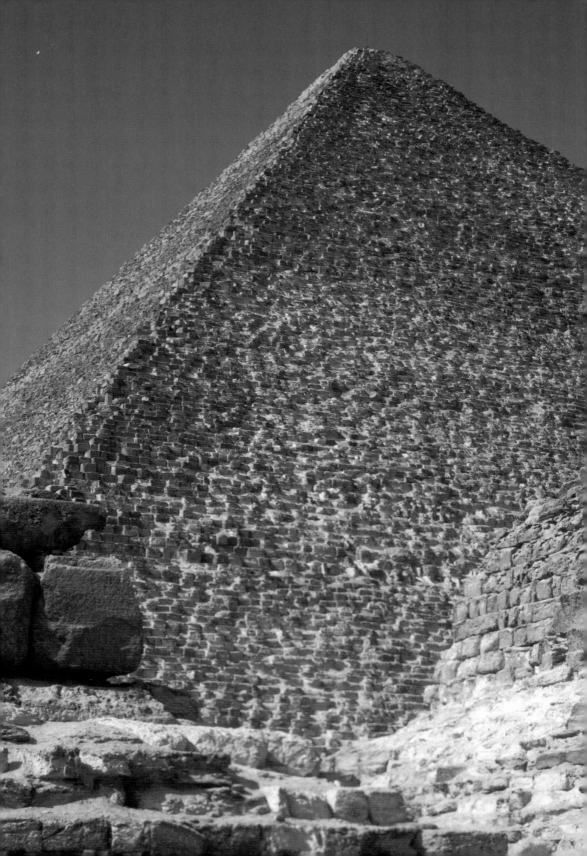

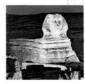

Preface

The Sound and Light Show at the Pyramids of Giza was inaugurated in 1961 under the supervision of Mr. Fouad Zaki Al-Arabi, beginning the first of a series of sound and light shows in Egypt, and becoming one of the top such projects in the world. This achievement is attributed to the chief contributor to the modern cultural boom, Dr. Tharwat Okasha, who modeled it after the Sound and Light Show of Versailles in France.

At that time, the equipment of the Sound and Light Show of the Pyramids was outdated and had to be operated manually. During each show, a group of eager, young graduates of the American University in Cairo would stand in front of a switchboard to control the lights as the taped dialogue and music played. Thus the show depended a great deal on the skill and knowledge of the operator, who had to ensure that the main elements of the show—dialogue, music, and lights—followed artistic direction closely.

Since then, the sound and light equipment has consistently been updated to keep up with newer and more advanced technology. The show has become more automated, needing only one engineer to monitor all of the equipment. The sound and light controls have been upgraded to computer-based

1

systems, enabling visual effects by laser beams. Moreover, giant video projectors and separate lighting systems have been introduced, and the languages in which the shows are conducted have increased from four to nine. Today the Sound and Light Show at the Pyramids is among the most popular tourists destinations in Egypt.

Finally, a new and comprehensive plan for the overall development of the Giza Plateau is being undertaken by the Ministry of Culture and the Supreme Council of Antiquities, under the supervision of Minister Farouk Hosny and Dr. Zahi Hawass.

On the forty-ninth anniversary of the inauguration of this project, we present *Wonders of the Pyramids* in collaboration with the American University in Cairo Press.

Essam Abdel Hadi
Chairman and Managing Director
Misr Company for Sound, Light, and Cinema

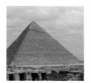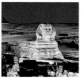

The Magic of the
Pyramids of Giza

by Zahi Hawass

Visitors come to the Giza Plateau and gaze upon the Great Pyramid of Khufu asking questions related to its construction. How could the Egyptians nearly five millennia ago have such engineering genius to erect monuments that modern man would be hard pressed to duplicate? What type of social structure was in place to allow for such wonders?

After so many centuries, the Great Pyramid holds many secrets yet to be revealed—one example being the mysterious doors uncovered inside the air shafts of the second chamber. The story of the so-called secret doors began over fifteen years ago when I took the decision to close off the Great Pyramid to tourists, as humidity levels inside rose to eighty percent. In order to solve this problem, we were considering the possibility of installing a ventilation system inside the pyramid. With the help of the German Archaeological Institute in Cairo (DAI), we hired robotics expert Rudolf Gantenbrink to clean out the shafts and install the ventilation system. Gantenbrink designed a small robot called Upuaut 2 for the task.

The project yielded interesting results—we located the exits of the shafts leading from the third chamber, and studied the manner in which the stone

blocks were interlocked within these shafts. I now truly understand why medieval Arabs said, "man fears time and time fears the pyramids." After sending the robot into the shafts of the second chamber we learned that the northern shaft bent at the nineteen-meter mark, a maneuver that the robot could not perform. While investigating the southern tunnel, the robot came face-to-face with a stone door fitted with two copper handles.

In 2001, I became a National Geographic Explorer and together, in 2002, we set out to reveal the secrets behind the mysterious stone door. A new robot was designed and sent into the southern tunnel of the second chamber, where we drilled a small hole in the door and inserted a miniature camera. What we saw amazed us: only a few centimeters behind the first door was a second stone slab. We then sent the newly designed robot up the northern tunnel—our research showed that it turns left, and then right after another eight meters. In designing the tunnel as such, the ancient Egyptian architects succeeded in avoiding the pyramid's Grand Gallery. The robot continued forward for another sixty-three meters until, much like in the southern tunnel, it was stopped by a door fitted with copper handles.

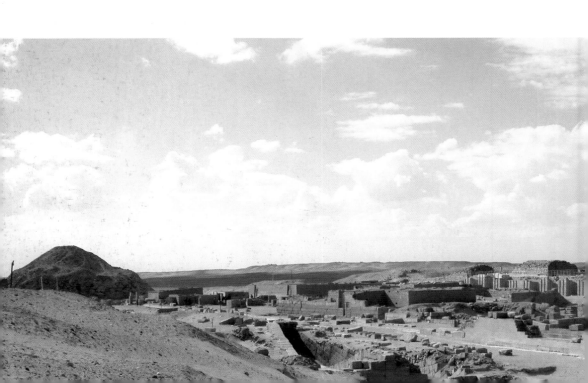

Eight years have passed since this last discovery, but I have been meeting with teams from Hong Kong, Singapore, and England, all eager to help solve the mystery of the stone doors. The Supreme Council of Antiquities (SCA) designed and built a tunnel similar to the ones found inside the Great Pyramid. Placed in the desert, the tunnel enables each team to demonstrate the performance and abilities of their robots. In the end, we chose a team made up of experts from Hong Kong, the University of Leeds, Tekron in Canada, and Protoneer in the United Kingdom to undertake the project.

Throughout pharaonic history, 123 pyramids were constructed for the kings and queens of Egypt of the Old and Middle Kingdoms (2650–1800 BC). The Egyptians chose the pyramidal shape because of its association with the ben-ben sacred stone, a conical stone structure. The word ben-ben was also used to refer to the capstone of a pyramid. It is linked with the Heliopolitan creation myth in which Atum, the creator god, expands as a mound from the waters of creation of the god Nun. Thus the pyramid is thought to represent the primeval mound, a place of creation and rebirth. Both the pyramid and the ben-ben stone are also thought to symbolize the rays of the

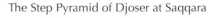

The Step Pyramid of Djoser at Saqqara

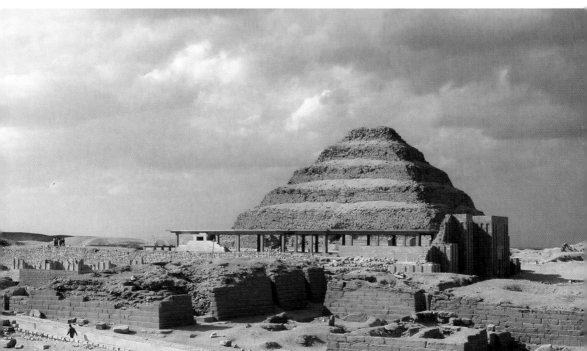

sun. An excerpt from the Pyramid Texts refers to the king as using the rays of the sun as a ramp in order to ascend to the sun and be linked with the god Re.

The Giza Plateau, where three very important kings of the Fourth Dynasty were buried, represents the peak of Old Kingdom history. The Old Kingdom, however, began with the reign of King Djoser, whose Step Pyramid was built by the architect Imhotep at Saqqara during the Third Dynasty. The subsequent dynasty began under Sneferu, the father of Khufu. He is thought to have built four different pyramids. The first is located at Seila in the Fayum, and does not have a burial chamber. Scholars have therefore suggested that it was a symbolic construction representing the primeval mound or that it marks the location of the king's provincial residence, and so is a symbol of power. Sneferu would have used this residence as a rest house when collecting taxes for the construction of his pyramid.

The second pyramid of Sneferu is located at Meidum. This pyramid was initially designed as a step pyramid, but the king abandoned the project and moved construction to the site of Dahshur. There, he constructed the so-called Bent Pyramid—halfway through the completion of the pyramid the architect decided to change its angle, thus creating a bend in its elevation. When the project was finished the pyramid was encased with fine, white limestone. The complex includes a subsidiary pyramid in the south, a chapel in the east, and a temple that was discovered in the valley decorated with scenes of the king's estates bearing produce towards the royal statues. Recently, a German team working at the site found part of the causeway connecting the mortuary temple to the valley temple, as well as more decorated reliefs from the valley temple.

Sneferu also built the Red Pyramid (North Pyramid) at Dahshur, which may be the first true pyramid erected in Egypt. After its completion, the king once again returned to the site of Meidum and altered the design of his step pyramid into that of a true pyramid. Thus, Meidum represents the beginning and end of Sneferu's fifty-four-year reign.

Sneferu's successor and son, Khufu (Cheops), moved the court to Giza, where his architect, Hemiunu, began the construction of the Great Pyramid. Khufu's son, Djedefre, chose modern Abu Rawash as the location of

his pyramid, while his other son, Khafre (Chephren), and his grandson, Menkaure (Mykerinos), returned to the site of Giza for the construction of their pyramids. The kings of the Fifth Dynasty moved their capital to Saqqara and built their pyramids both at Saqqara and Abusir, and those of the Sixth Dynasty had their pyramids built north and south of Saqqara. The pyramid of Ibi, an Eighth Dynasty ruler, is also buried in South Saqqara.

The pyramids at the Giza Plateau are the largest pyramids in Egypt. Visitors often wonder how the Egyptians were able to move stone blocks weighing over three tons each to build such colossal structures. It is important to point out that each pyramid in Giza was built differently from the next. Furthermore, each pyramid is part of a larger complex that includes temples and other structures for the purpose of maintaining the cult of the king. A study conducted by Mark Lehner demonstrated that the stone blocks used in the construction of the pyramids at Giza were quarried at Giza.

The quarry associated with the Great Pyramid is located to the south of the pyramid, and east of the pyramid of Khafre. The quarry's location, as well as the construction of a ramp, explain the location of Khufu's subsidiary pyramids, which is different from that of every other Old Kingdom pyramid. The ramp used in the construction of the Great Pyramid was made from stone rubble and mud. During my excavations south of the Great Pyramid on both sides of Pyramid Road, I discovered remains from its lower section. We determined that this structure was the remains of a permanent ramp that led from the quarry to the southwest corner of the main pyramid.

In order to begin the construction of the Great Pyramid, the ancient Egyptians carved out an eight-meter-high base in the solid rock. Some archaeologists believe that the Egyptians built a spiral ramp that wound its way around the pyramid, and was removed after construction was complete. During our excavations, however, we found evidence of a straight-on ramp on the edge of the northern side of the pyramid. Finally, the pyramid was topped with a capstone that was encased with electrum.

The Great Pyramid was a national project. Every household from north to south supplied the workforce and sent food to the workmen. During one of my excavations at Giza, we discovered the tombs of the builders. The

lower cemetery was reserved for the workmen who moved the stones and died during the construction phase—these men came from various regions in Egypt, and took turns every three months. Their tombs were made of mud brick, and were shaped as small pyramids or mastabas with vaulted ceilings and limestone false doors. The bodies were buried approximately two meters under the ground. A study of these skeletons showed that both men and women suffered from back problems as a result of moving heavy objects. One individual had an amputated leg, while another had developed cancer, underwent surgery, and lived for a further two years.

The upper cemetery was reserved for technicians and artists. Their tombs were built of mud brick and limestone. Inside, we found titles such as tomb-maker, draftsman, craftsman, overseer of the harbor, and overseer of the workmen who move the stones. Recently, my team and I found the tomb of an overseer called Idu. His tomb was surrounded by smaller shafts in which his workmen were buried. Archaeological evidence shows that these tombs date to the beginning of the Fourth Dynasty, when the Great Pyramid was being built. To the east, Lehner uncovered the workmen's

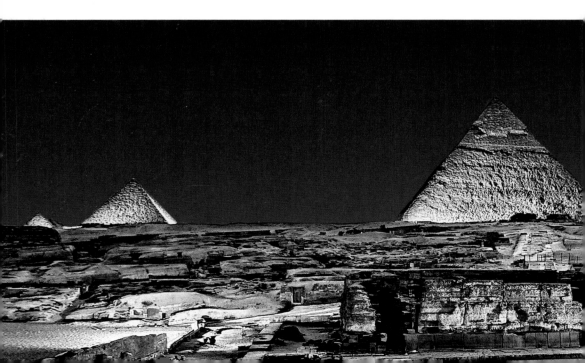

installation complex, which included bakeries and homes. He was also able to determine from examining animal remains that eleven cows and thirty-three goats were slaughtered every day to feed ten thousand workmen.

The casing of the Great Pyramid was made from fine, white limestone taken from the royal quarry at Tura. It has been estimated that the pyramid contains approximately 2.3 million blocks. Its sides are measured at about 230.33 meters at its base, and in ancient times it rose to about 146.5 meters high. Currently, it measures 137.33 meters in height—it has lost a total of nine meters over the centuries. The angle of the Great Pyramid is 51° 50' 40".

The modern entrance used by visitors today is called the Mamun entrance; according to legend, it was the result of a forced entry by Caliph al-Mamun around AD 820. In 1646, John Greaves describes, in his accounts, climbing a mound of rubbish to the original entrance, which had been exposed with the removal of the outer casing.

There is a passageway that slopes down for 100 meters from the main entrance to an unfinished room cut out of solid bedrock (the Subterranean Chamber). This room was probably the first burial chamber, but it remains

The Pyramids and Sphinx of Giza

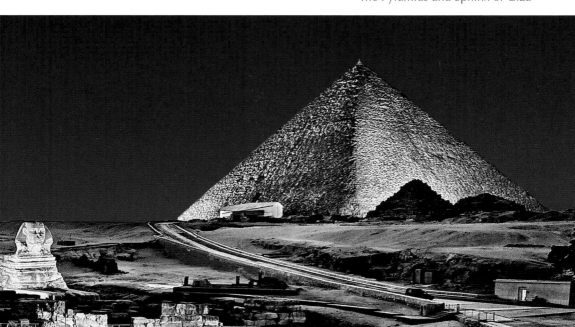

unfinished. Scholars theorize that when the overseer of works reached this point in the construction he decided to enlarge the architectural plans. First, he cut a hole in the roof of the descending passageway. Then, he constructed a new passageway leading upward (the Ascending Passage) through the core of the pyramid ending in a dual passage. The first leads directly into the second burial chamber, the so-called Queen's Chamber, which was also never finished. Perhaps this room contains secrets yet to be discovered. I do not believe that this room was intended to be used as a burial chamber. This is due in part to the investigation we conducted on the northern and southern air shafts using a robot.

In order to ascend further up the pyramid, the overseer built a passageway with a corbelled roof (the Grand Gallery), which gives access to a low, narrow passage (the Antechamber) leading into the king's red granite burial chamber. Located in the western end of the chamber is Khufu's granite sarcophagus. The air shafts in the burial chamber were constructed, in my opinion, so that the king's soul could leave the pyramid to accompany the god on his solar boat. Above the king's chamber are five stress-relieving chambers, which can be reached through a small opening at the end of the Grand Gallery just before the entrance to the third room. They were probably built in order to divert the enormous weight of the pyramid from the roof of the burial chamber. I have entered these relieving chambers on numerous occasions. It is always interesting to climb into each chamber and look at the graffiti left behind by the workmen who built the pyramid. In the fifth room, one graffito reads 'Friends of Khufu.'

What caused the overseer to change the location of the burial chamber from beneath the pyramid to within the pyramid? I believe that during the construction of the pyramid Khufu's cult changed and he himself became Re, the sun god. (The living king was normally identified with the god Horus, only to become Re after death.) This theory is based on the following evidence: the pyramid of Khufu was referred to as the 'Horizon of Khufu,' thus indicating that the king was equated with the sun god because, like the sun god, the king would set into his horizon after death. Furthermore, his sons Djedefre and Khafre were the first two kings to bear the title 'Son of Re.'

Lastly, the pyramid of Khufu is the only pyramid from the Old Kingdom where the burial chamber is above ground. Since the pyramid shape was associated with the ben-ben stone, the symbol of the sun god or of the primeval mound, the king's elevated burial chamber is a further association with Re.

The pyramid complex of Khufu was surrounded by an enclosure wall. Its remains are visible on the north and east sides. A court area was constructed between the pyramid and the enclosure wall fitted with a limestone pavement. Evidence of the mortuary temple is still visible on the east side where a threshold of basalt still remains. Green lines appear on the basalt in the sunlight; green is the color of fertility and agriculture, both of which are associated with the king.

During the Middle Kingdom, Khufu's mortuary temple was used as a quarry; numerous blocks from this monument were reused in the construction of the pyramid of Amenemhat I at Lisht. The temple's sanctuary was also reused as a tomb in the Twenty-sixth Dynasty. The plan of the temple shows an entrance to the east and a court area decorated with five niches that once contained statues, one for each name of the king. Later in the Old Kingdom, the temple was enlarged and the angle of the causeway was altered. I also think that an altar flanked by two stelae stood on a platform next to the pyramid.

The mortuary temple entrance opened on a causeway, which probably resembled a corridor built on the bedrock of the plateau. During the fifth century BC, Herodotus described the causeway as being decorated and roofed. During our excavations at the site, we discovered evidence proving this. We also followed the causeway to the village of Nazlet el-Saman, until it reached the valley temple, the location of which was previously unknown. We could not excavate and determine the plan of the valley temple because it rested under a new villa in the village. We did, however, discover that like the mortuary temple it was paved with basalt.

The project to construct a sewage system for the village enabled us to uncover a large settlement east of the valley temple. This might demonstrate that the royal residence at the time was in Giza, and that the king

ruled the entire country from there. We also think that the pyramid town, where the priests who maintained the royal cult lived, might be situated south of the valley temple.

East of the Great Pyramid are three smaller pyramids built for queens. The northern one, according to Mark Lehner, could belong to Queen Hetepheres I, the mother of Khufu. The middle pyramid could have been constructed for Queen Meretites, while the southern pyramid might have belonged to Henutsen. Each pyramid was linked to a small chapel. The chapel of Henutsen's pyramid was enlarged during the Twenty-sixth Dynasty and converted into a temple for the goddess Isis.

In 1925, east of the northern pyramid, Geroge Andrew Reisner discovered the funerary equipment of Queen Hetepheres I, now on display at the Egyptian Museum. After his discovery, Reisner hypothesized that Hetepheres was initially buried at Dahshur, but that Khufu had ordered the contents of the queen's tomb removed then transferred to Giza. Mark Lehner, however, has suggested that Khufu's mother was first buried in the northern pyramid. When the architectural plans of the complex changed, the northern pyramid was reassigned as the king's ritual pyramid and Hetepheres was allocated the middle pyramid. In my opinion, Hetepheres was originally buried inside the northern pyramid. During the First Intermediate Period, when the complexes of Khufu and Khafre were destroyed, loyal priests moved her funerary equipment into the nearby shaft, which is typical of the Third Dynasty, in order to protect her belongings.

Recently, we discovered the ritual pyramid of Khufu located at the southeast corner of the Great Pyramid. We unearthed its T-shaped burial chamber, the entrance, as well as the capstone of the pyramid. The construction of the ritual pyramid was initially planned north of the causeway within the substructure of the so-called trial passage; this has a similar substructure to the Great Pyramid. When the mortuary temple was enlarged, however, the angle of the causeway needed to be altered. The superstructure of the ritual pyramid was abandoned and moved to the newly assigned location. The ritual pyramid was used as a symbolic changing room where the king would leave his robe and crown in order to change into a kilt so that he

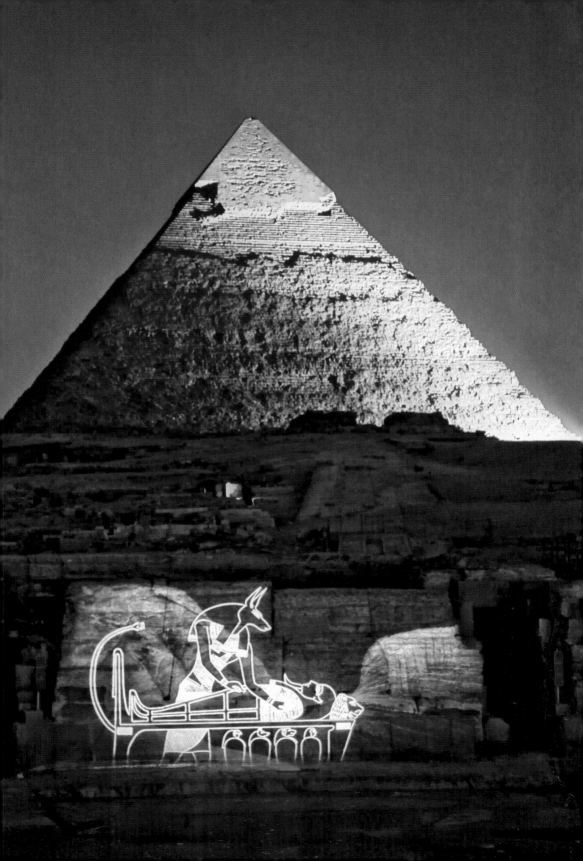

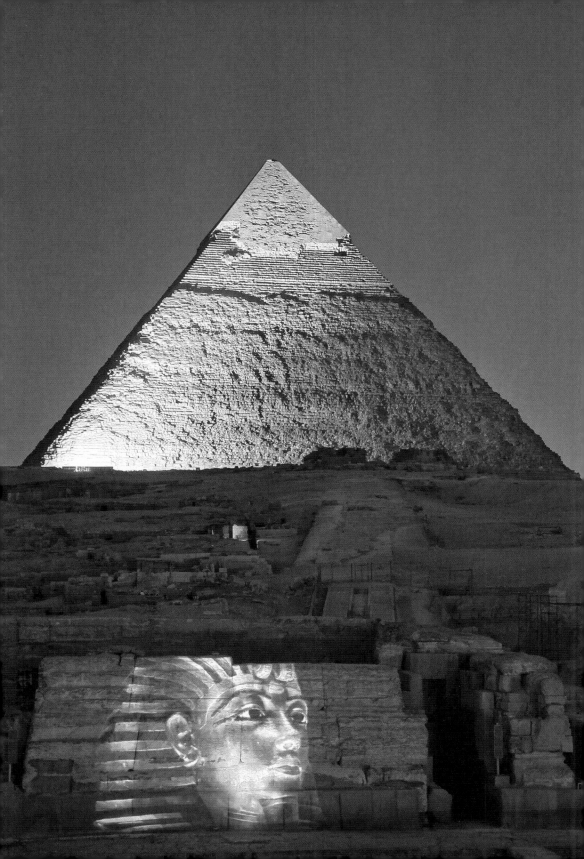

might perform the Sed-festival outside. The ritual demonstrated to all that he had performed all the functions required by the universal god.

Five boat pits associated with the pyramid complex of Khufu have been discovered: two on the southern side of the pyramid, two located to the north and south of the mortuary temple (one on each side), and one next to the northern queen's pyramid. The southern boat pits were discovered in 1954 by Kamal el-Mallakh. Inside the southeastern one, he uncovered a full-sized, dismantled wooden boat. A similar one was found in 1987 by a team of archaeologists associated with National Geographic when they drilled a small hole and inserted a camera into the southwestern boat pit. It is thought that the king would use the solar boats to accompany the god Re on his daily trips across the sky. One type was used by day *(ma'njet)* and another was used by night *(mesketet)*. The oars were used by the god to kill wild creatures during the journey, thereby protecting the people and gaining their love and worship. The first boat is currently housed within a museum at Giza on view to the public. The second boat, located south of the pyramid, is under restoration by a team from Waseda University.

The two boats located to the north and south of the mortuary temple were used by the king to control Upper and Lower Egypt, while the last boat served the cult of the goddess Hathor. The gods Re, Horus, and Hathor were worshiped as the triad of Giza. Re was revered within the mortuary temple, while Horus (as the living king) was worshiped in the valley temple. Finally, Hathor was praised in the temple located east of the subsidiary pyramid. Re was the head of the triad while Hathor was thought of as his eyes as well as the wife of the living king, and the mother of the succeeding king.

Recently, Egyptologists found evidence that Khufu sent an expedition to the Western Desert during his twenty-seventh year in order to bring back *mafet* red paint. This new evidence demonstrates that the Turin Papyrus king list, which states that the king ruled for twenty-three years, is incorrect. Egyptologists now believe that Khufu was on the throne for thirty to thirty-two years.

After the death of Djedefre, Khafre took the throne and built his pyramid next to that of his father, Khufu. His pyramid is called 'Great is Khafre.' It rises 143.5 meters, and is 215 meters long at the base. It is angled at 53° 10'.

The pyramid has two entrances, both constructed during the Old Kingdom. This is different from the Great Pyramid, which has only one entrance. The pyramid of Khafre also has two burial chambers, one of them containing a sarcophagus. The whole pyramid was encased with fine, white limestone, but only the top of the pyramid still bears part of its casing.

A three-meter-high enclosure wall surrounded the pyramid complex. East of the pyramid is the mortuary temple; it is the most complete mortuary temple dated to the Fourth Dynasty. The temple was excavated in 1909–10 by German scholar Uvo Hölscher, who discovered that it had been paved with calcite. It is surrounded by five boat pits that probably have the same function as Khufu's boats. A subsidiary pyramid is built on the south side of Khafre's pyramid. Its burial chamber is still visible through the many scattered blocks. Inside the burial chamber, archaeologists found pieces of wood that could be from a coffin and other artifacts that suggest that the pyramid was used for the burial of a queen. West of the pyramid, we discovered a passage with evidence that it once contained a statue.

William Flinders Petrie excavated in an area west of the pyramid of Khafre, an area that scholars today call the Workmen's Barracks. He discovered long and narrow rooms with windowless walls of limestone and suggested that the workmen who built the pyramid used the area as a barracks. In 1989, in cooperation with Mark Lehner we re-excavated the area and determined that it could not have been a settlement, but rather a workshop for the storage of artifacts used in the royal cult, as well as for the manufacture of objects used in the temples.

The causeway linked with the complex of Khafre may well be one of the most complete ever found. It is built of fine, white limestone and decorated with numerous scenes. It leads to the valley temple, which was built with limestone and encased with granite. The valley temple has two eastern entrances: one inscribed with the name of Hathor, and another inscribed with the name of Bastet. The main room is T-shaped and contains sixteen pillars. Originally twenty-three calcite, diorite, and schist statues stood lining the walls. The temple was used for the worship of the king as Horus. Evidence shows that purification was done outside the temple. Recently, we found two

ramps in front of the temple entrance connecting them to the harbor, itself situated east of the valley temple and linked with the Nile by a canal.

Another feature that most likely belongs to Khafre's complex is the Great Sphinx. This monument is the first colossal statue ever constructed in ancient Egypt. The divine beard was originally visible, as was the nose, which was probably destroyed in AD 1378 by a religious zealot called Sheikh Muhammad Sa'im al-Dahr.

The Great Sphinx spans a length of 72.55 meters from the tip of the front paws to the back of the rump. It rises 20.22 meters and is 19.10 meters wide. Throughout Egyptian history, the Great Sphinx remained Egypt's largest sculpted statue, even larger than the Colossi of Memnon that remain of the temple of Amenhotep III on the Theban west bank.

Lying north of the eastern end of Khafre's causeway, the Sphinx faces east toward the rising sun. Before it are the remains of a limestone temple that was meant to be cased with red granite from Aswan (the builders finished only the interior with granite casing). The Great Sphinx was carved directly out of the living rock of the Muqattam formation, the limestone outcropping of the Giza Plateau.

The Greek word 'sphinx' likely comes from the Egyptian *shesep ankh*, meaning 'living image.' It expresses the link between sphinxes and the king who is a living image of the sun god. It is, therefore, an icon of kingship and symbolizes the power of a lion with the intelligence of a man. The Sphinx is also linked with solar worship; the Sphinx temple has an open court with niches on both the eastern and western sides, built for the rituals of the rising and setting sun. The temple also contains twenty-four pillars representing the twenty-four hours of the day and night. The Great Sphinx also embodies the king as a warrior and as protector of his people.

The identity of the builder of the Great Sphinx has spurred debate among Egyptologists for many years. Some scholars, such as Rainer Stadelmann, have argued that Khufu was responsible for its creation. I and others believe that the monument more likely dates to the reign of Khafre. Archaeological evidence suggests that it is part of his pyramid complex. Its location and the architectural similarity of its temple to Khafre's valley temple, the terrace on

which both temples are built, and the fact that some of the temples' walls are aligned—all are strong points in favor of this identification.

After the Old Kingdom, activity surrounding the Great Sphinx continued. New Kingdom pharaohs came to Giza to hunt desert animals and to pay homage to the Sphinx. Amenhotep II, who ruled during the Eighteenth Dynasty, built a small temple on the terrace northeast of the statue. Thutmose IV conducted the first restoration project, which removed the sand that surrounded the monument. The pharaoh then erected the Dream Stela, a text carved on a reused granite door lintel, and set it up between the paws of the Sphinx. The story tells of the young prince Thutmose falling asleep by the statue during a desert hunt. In a dream, the Sphinx promised to make him king should he clear away the surrounding sand, a task that he took on accordingly. In the Nineteenth Dynasty, Ramesses II added two stelae flanking the open-air chapel between the Sphinx's paws. He also built a huge mud brick wall to the north of the Sphinx. In our recent excavation we found that this wall extended to the east of the Sphinx temple and the valley temple. Further restoration work was conducted during the Twenty-sixth Dynasty and the Greco-Roman period.

In April 2008, a team from the Supreme Council of Antiquities, under my direction, drilled five holes twenty meters in depth in order to solve the rising groundwater problem: one next to the left paw, one on the right paw, one between the two paws, and two on the back of the Sphinx. We also inserted a probe inside the hole near the left paw, but nothing was found, thus providing evidence that no hidden chambers lay beneath the Sphinx, as some had claimed.

The last of the Great Pyramids belongs to Menkaure, who was the son of Khafre and the grandson of Khufu. He built his pyramid to the south of the pyramid of his father. It is the only pyramid in Giza that is encased, for a third of its height, with granite as opposed to limestone. The pyramid of Menkaure was named 'Menkaure is Divine.' It originally rose 65 meters, each side measuring about 102.5 meters at the base.

Reisner excavated the pyramid's mortuary temple and found fragments of royal statues including the shins of a larger-than-life statue that might

have been the centerpiece of the temple. We also found two walls surrounding the pyramid. The valley temple in Menkaure's complex is similar to later temples of the Old Kingdom. When Reisner excavated the structure, he found evidence of the presence of statues, such as the famous triads of Menkaure, as well as other objects. The semi-intact objects in both temples demonstrate how the cult of the king was maintained.

The pyramid of Menkaure is flanked to the south by three small subsidiary pyramids, each linked with a small temple. Remains of a pyramid town were discovered east of the valley temple as well as foundations of a purification tent to the south, and an industrial area excavated by Abdel Aziz Saleh. Menkaure died before the completion of his pyramid complex, and so it was completed by his son, Shepseskaf. Many additions were made to the complex during the Fifth and Sixth Dynasties.

The study of the architecture on the Giza Plateau—its temples, boats, and various features—along with the study of titles held by individuals of the Old Kingdom helps us to infer the function of the pyramid complex. Based on the Pyramid Texts, Herbert Ricke has suggested that it was used for the funeral of the king. However, there is no physical evidence to support this theory. The door leading from the mortuary temple to the pyramid court is very small and would not permit a funerary cortege to pass through. I believe that the funeral of the king came from outside the pyramid complex and entered through the northern entrance.

The Giza Plateau is a unique site; all of the important information it yields can be seen during the Sound and Light Show. While seated before the Sphinx, you will feel the magic of the Pyramids while listening to the voices of famous actors whom you may recognize. If you visit the site during the day, go on an adventure—enter the Great Pyramid of Khufu and gaze upon the Grand Gallery. At night, however, you will have the chance to listen to the stories that speak of the Pyramids of Giza, one of the original Seven Wonders of the World.

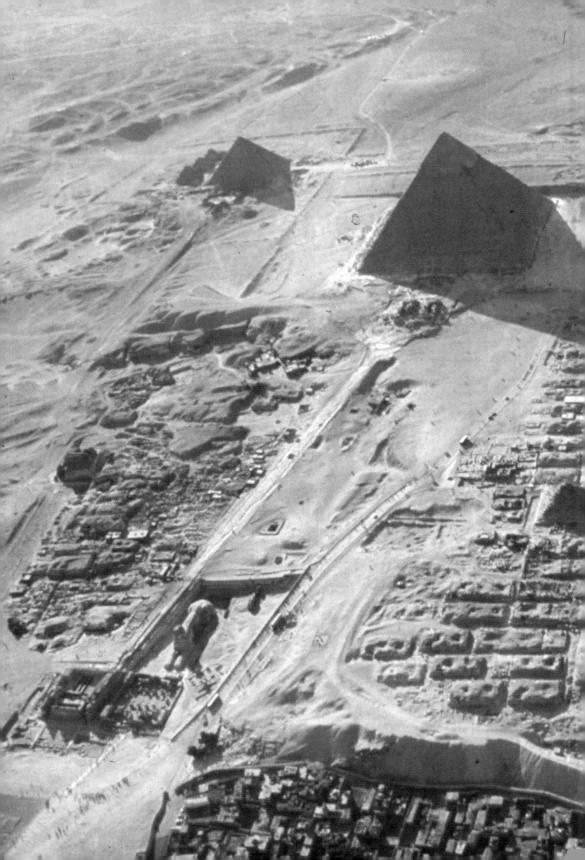

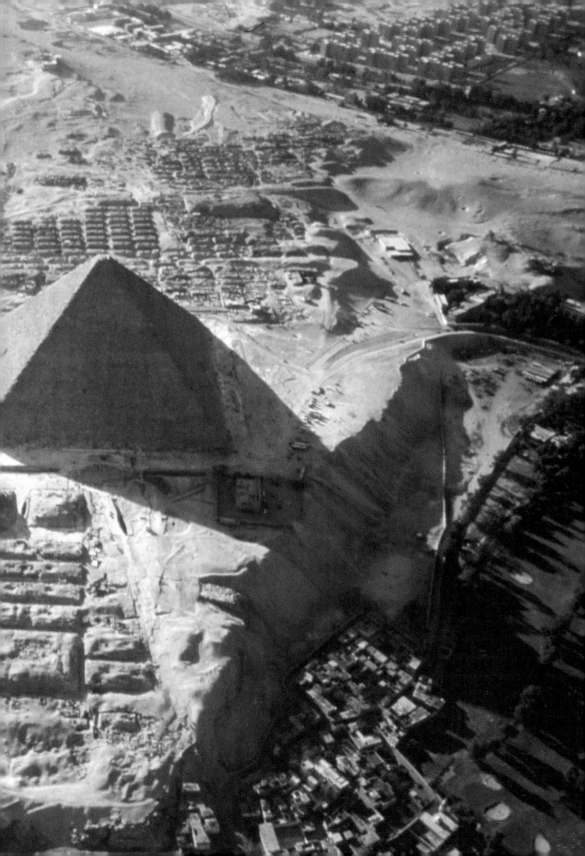

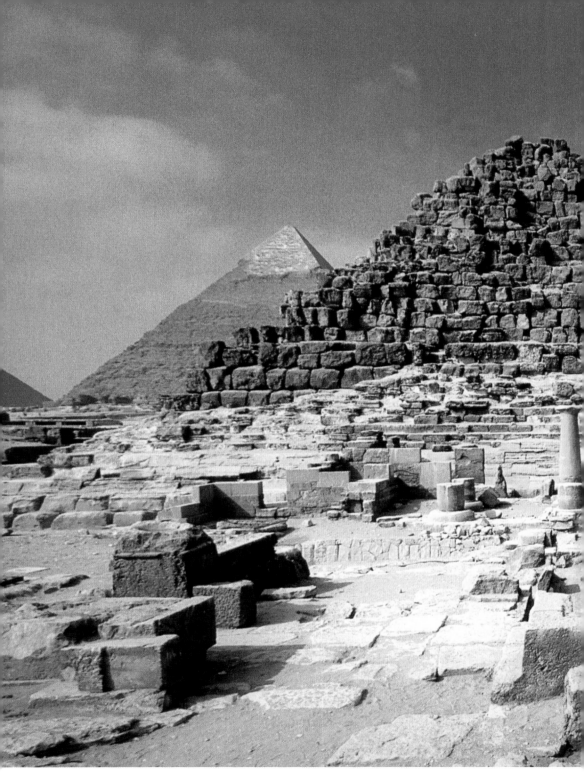

Previous pages: The Pyramids of Giza from the air

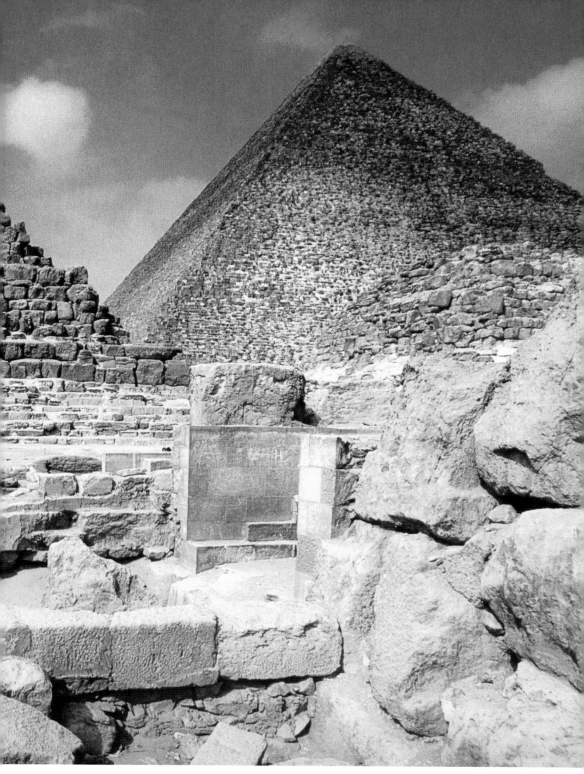

Above: The Temple of Isis at the Pyramids of Giza

Following pages: The Great Pyramid of Khufu

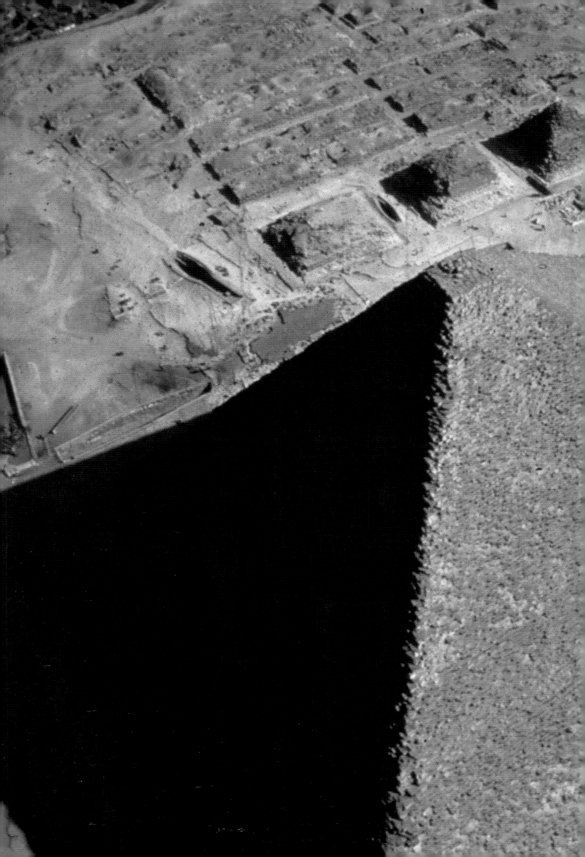

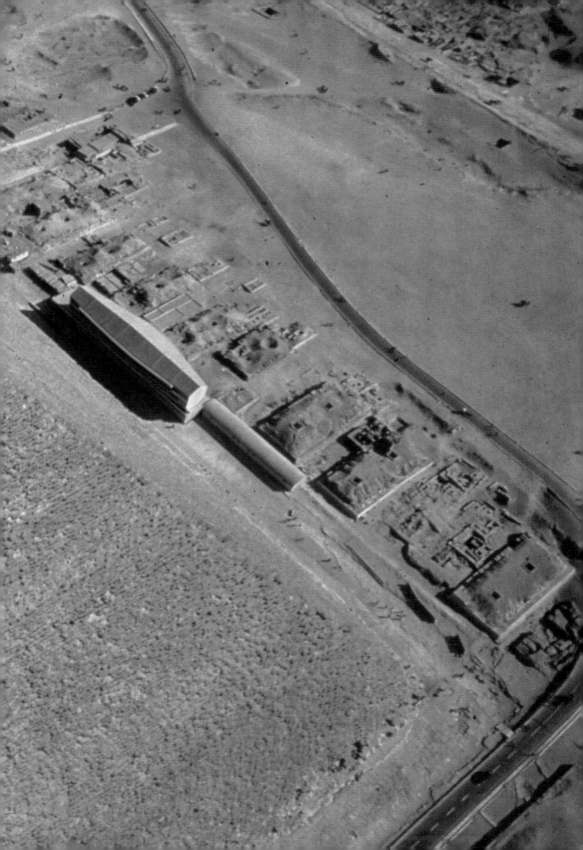

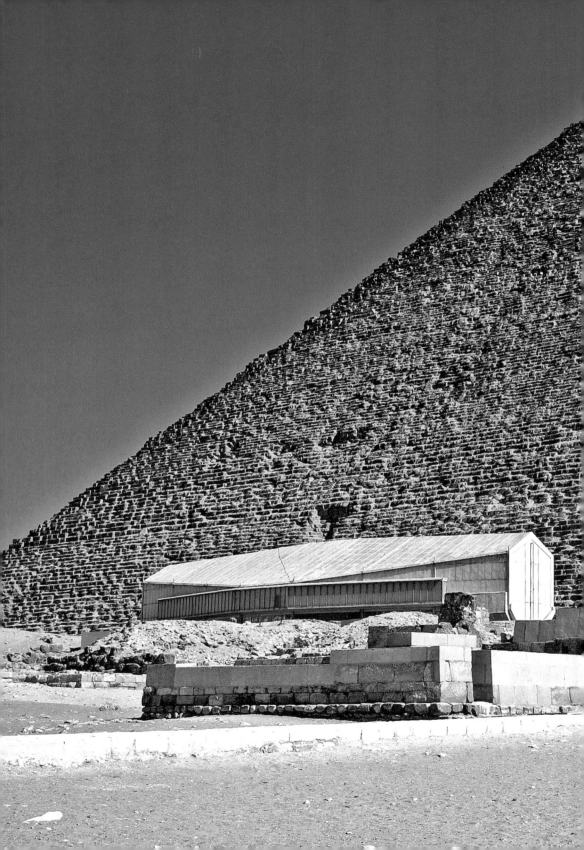

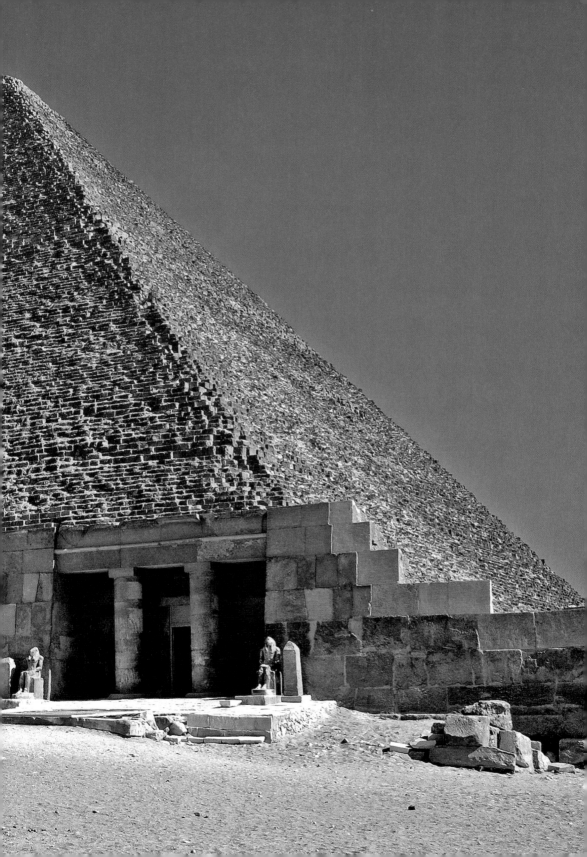

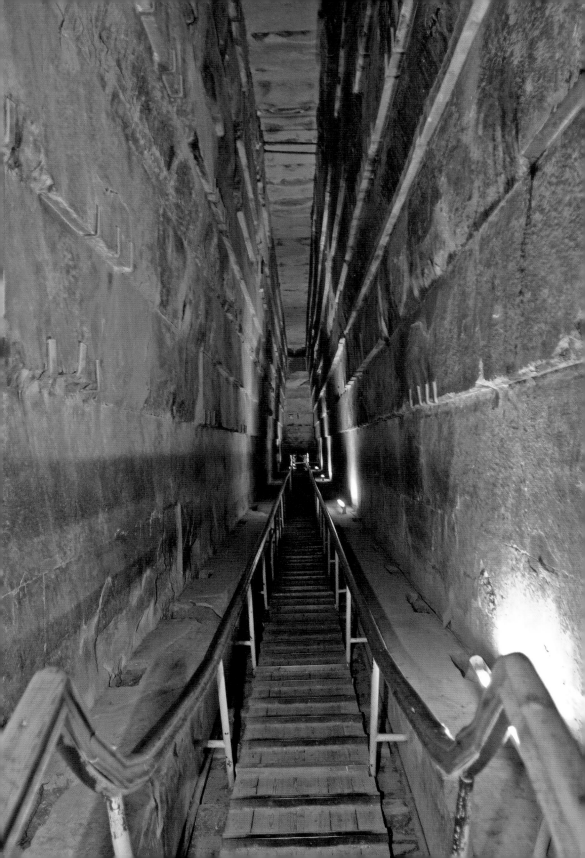

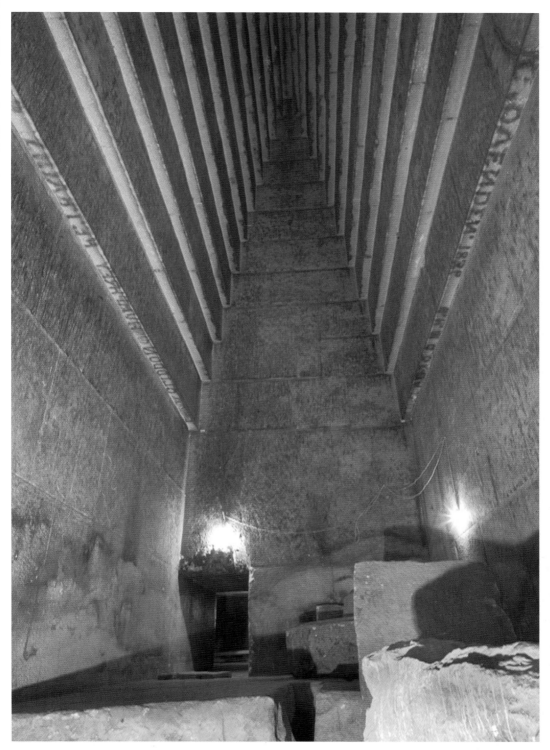

Above and opposite: The Grand Gallery inside the Great Pyramid

Previous pages: The Solar Boat Museum and the mastaba tomb of Seshemnefer IV in front of the Great Pyramid of Khufu

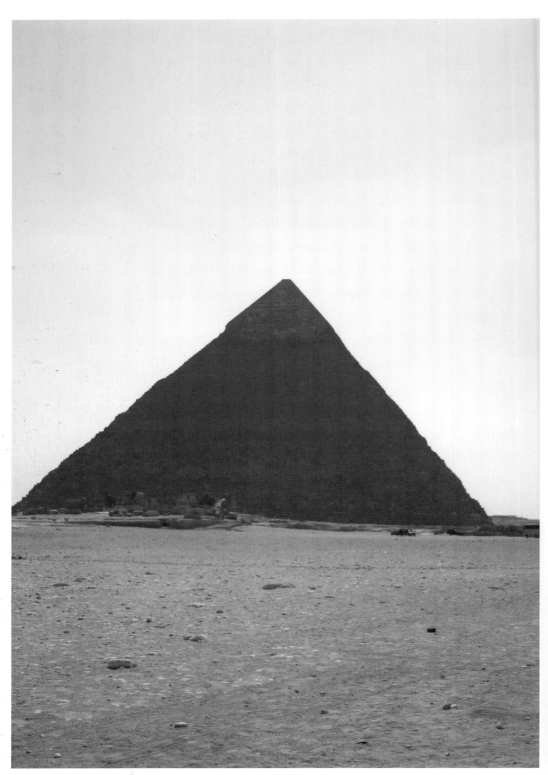

Above, opposite, and following pages: The Pyramid of Khafre

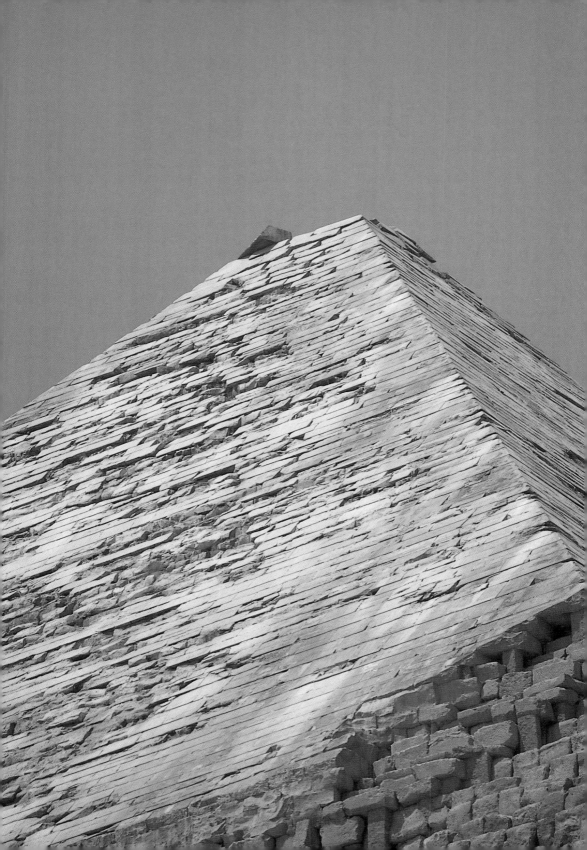

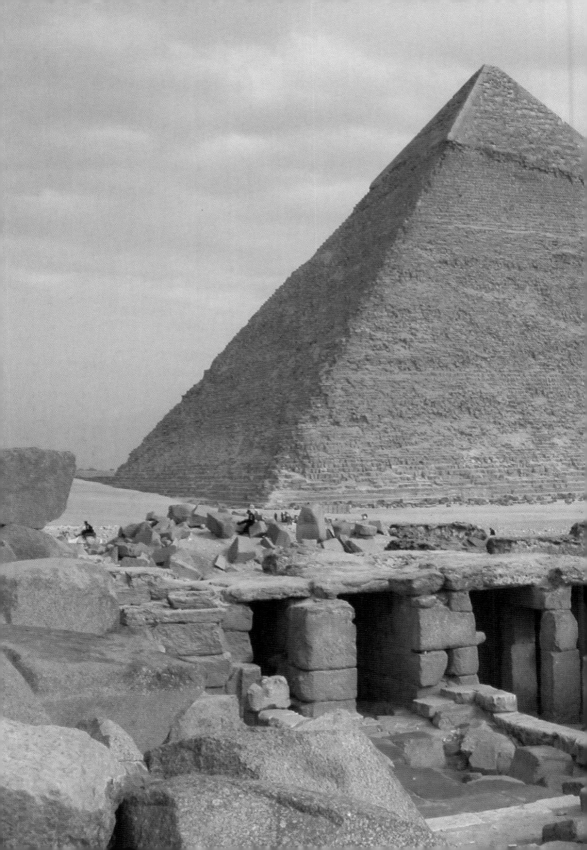

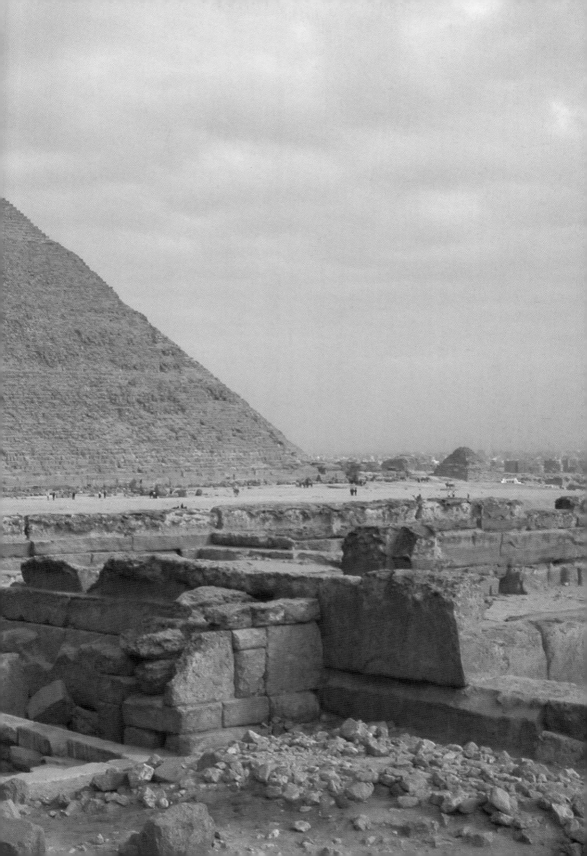

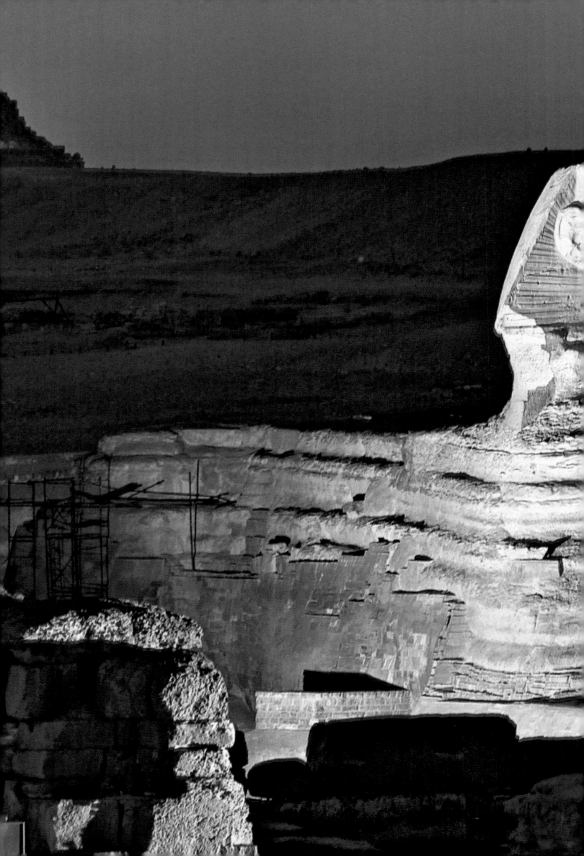

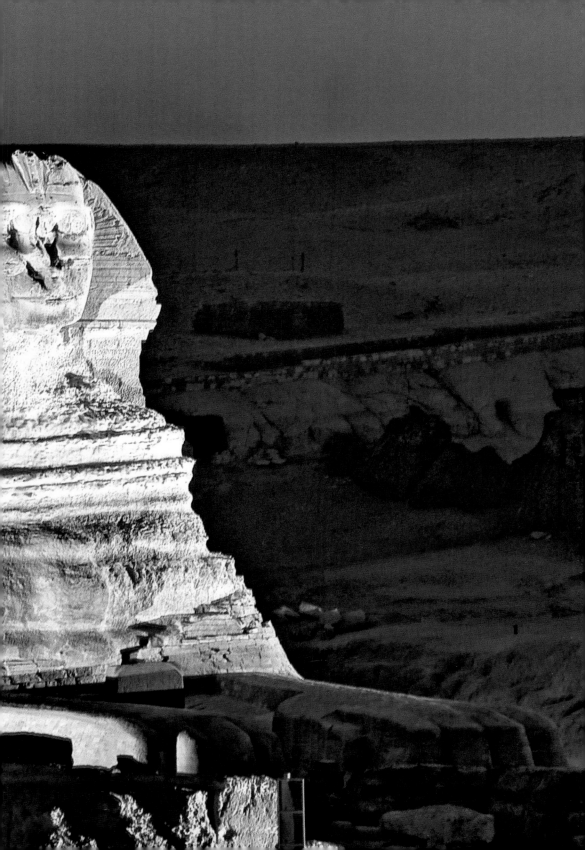

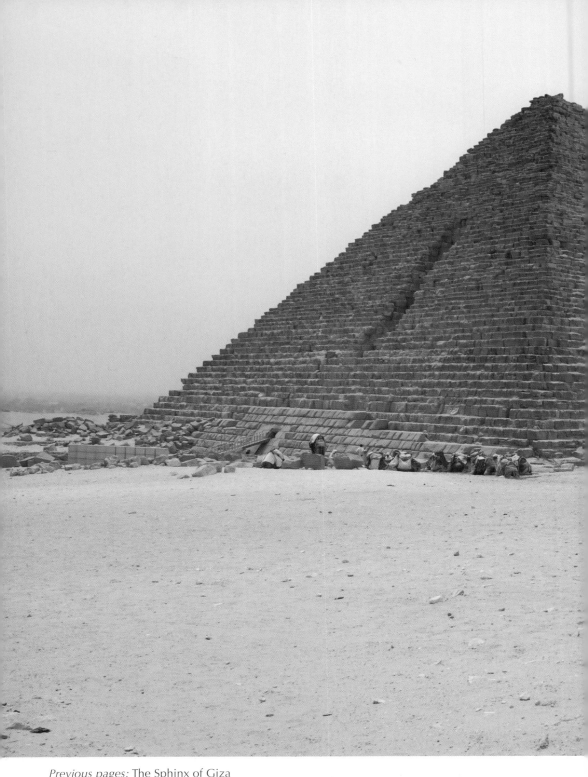

Previous pages: The Sphinx of Giza

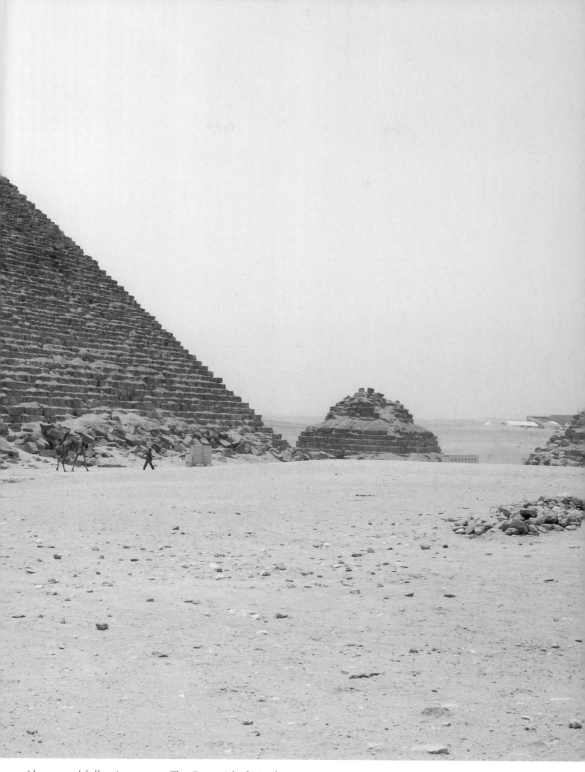

Above and following pages: The Pyramid of Menkaure

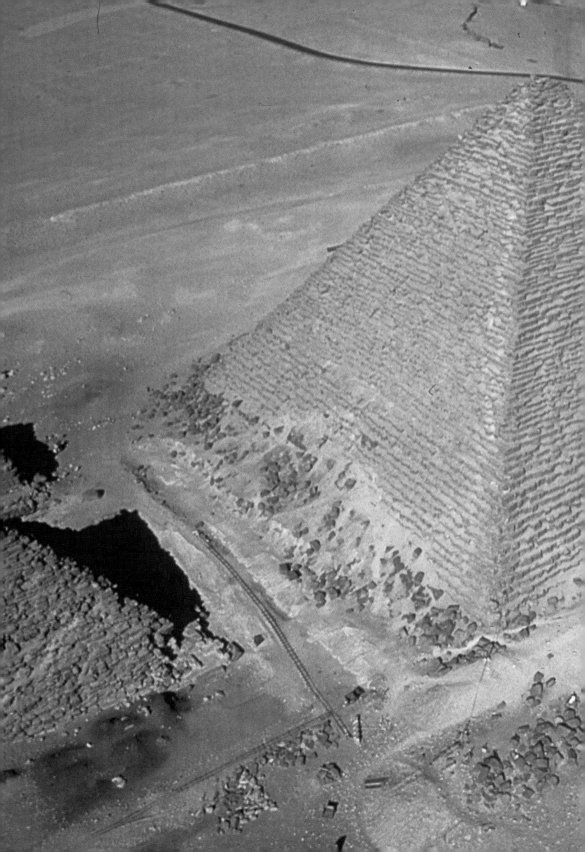

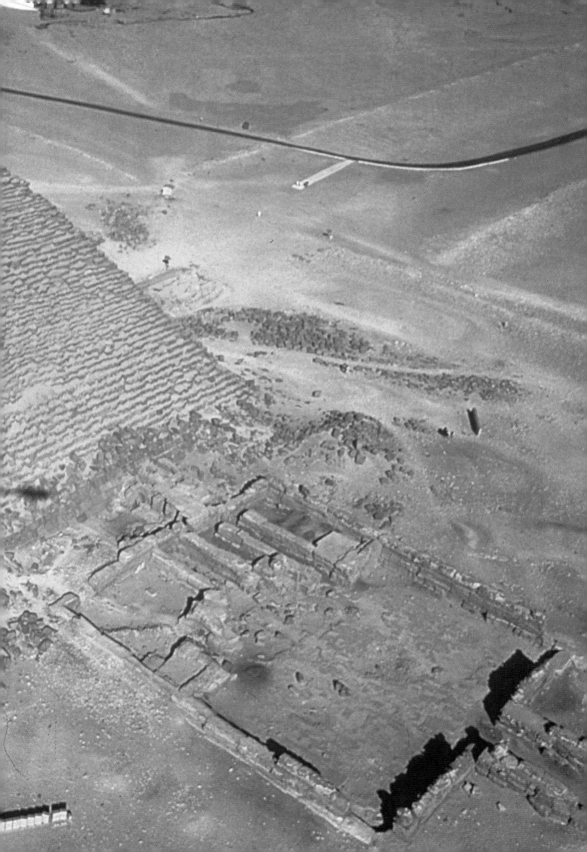

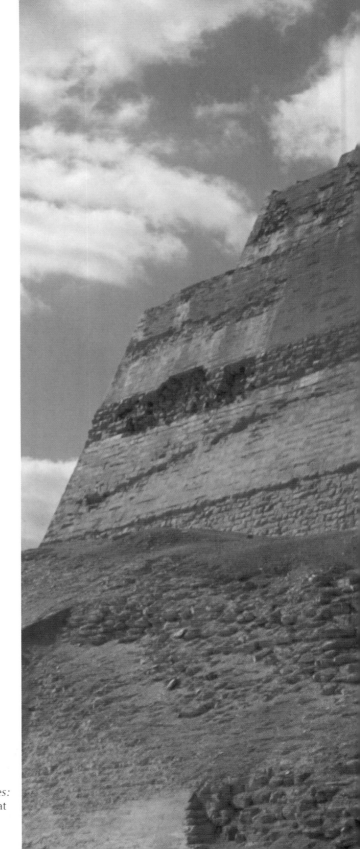

Right and following pages:
The Pyramid of Sneferu at Meidum

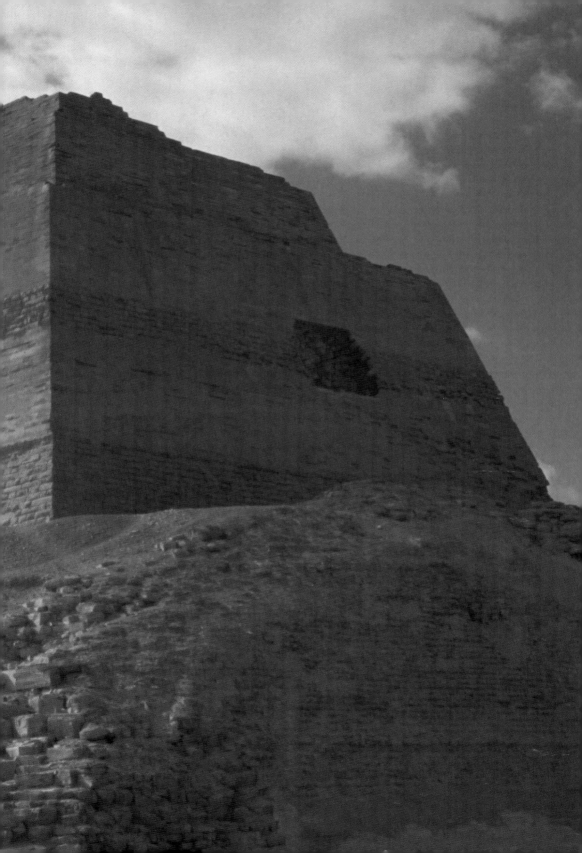

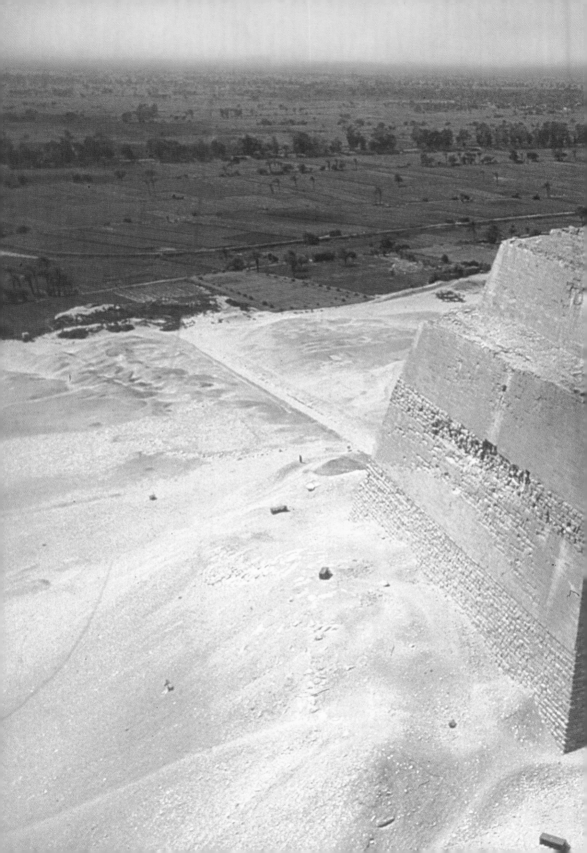

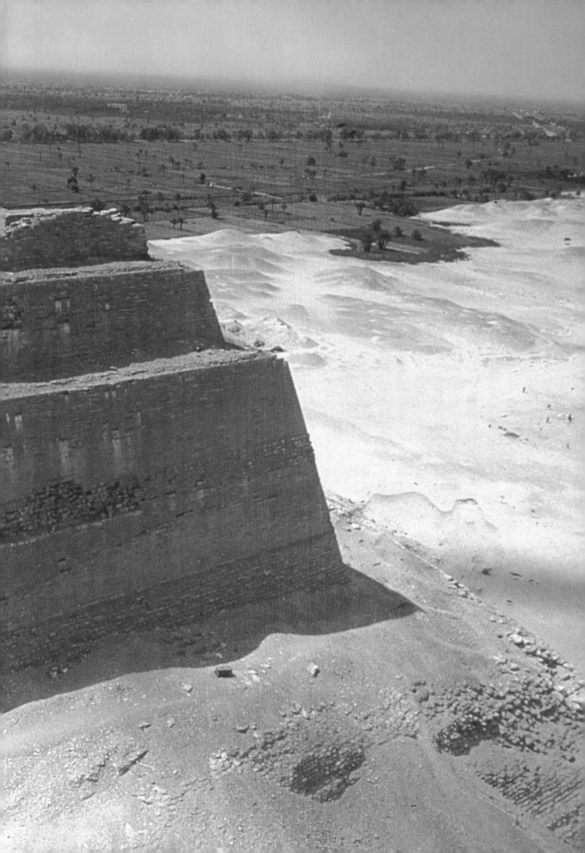

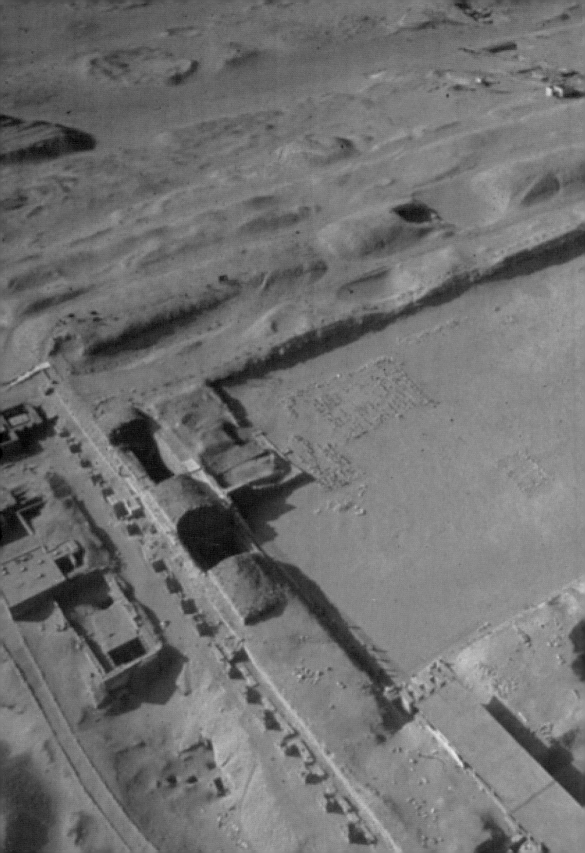

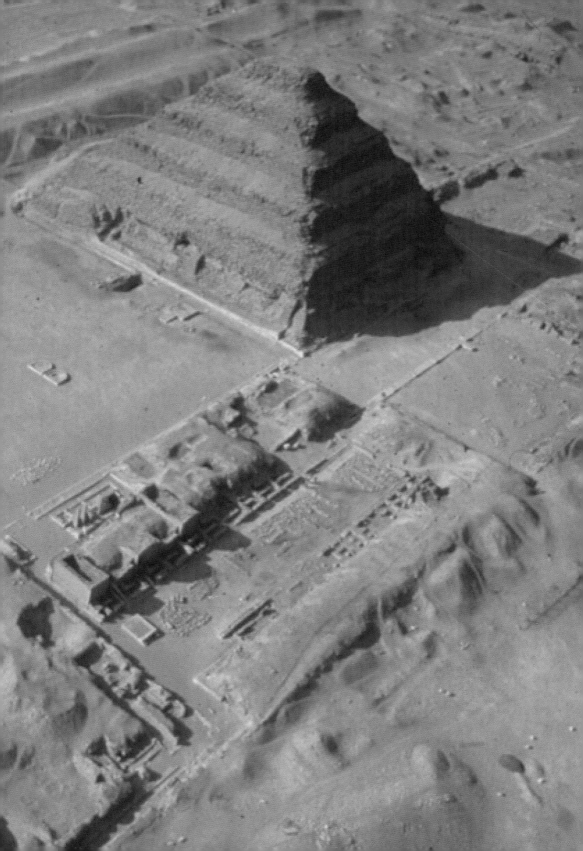

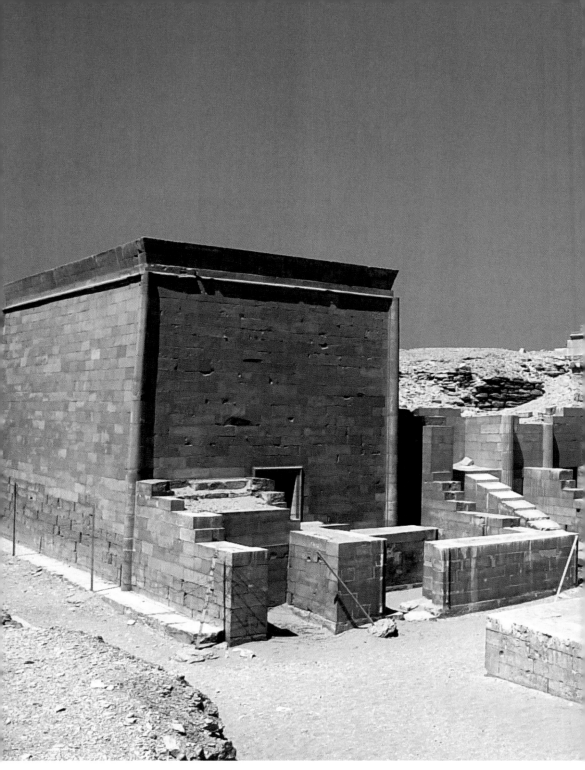

Above and previous pages: The Pyramid of Djoser at Saqqara

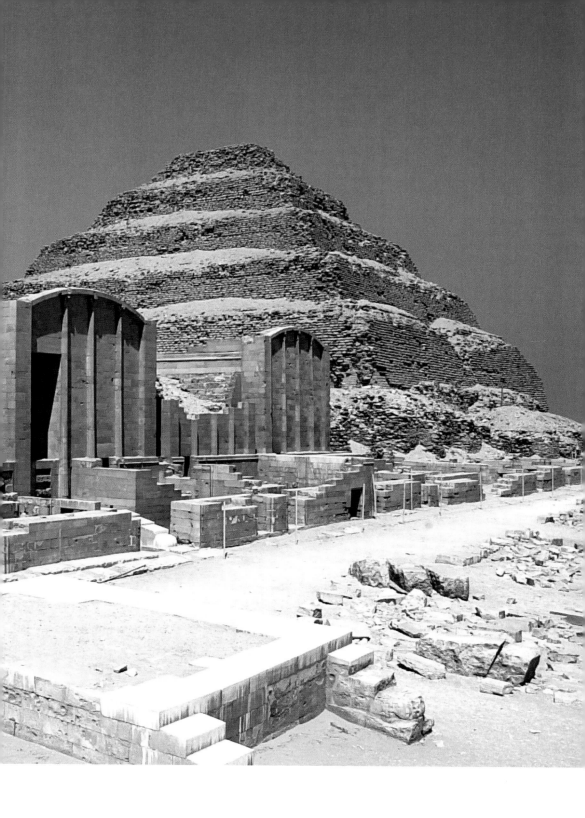

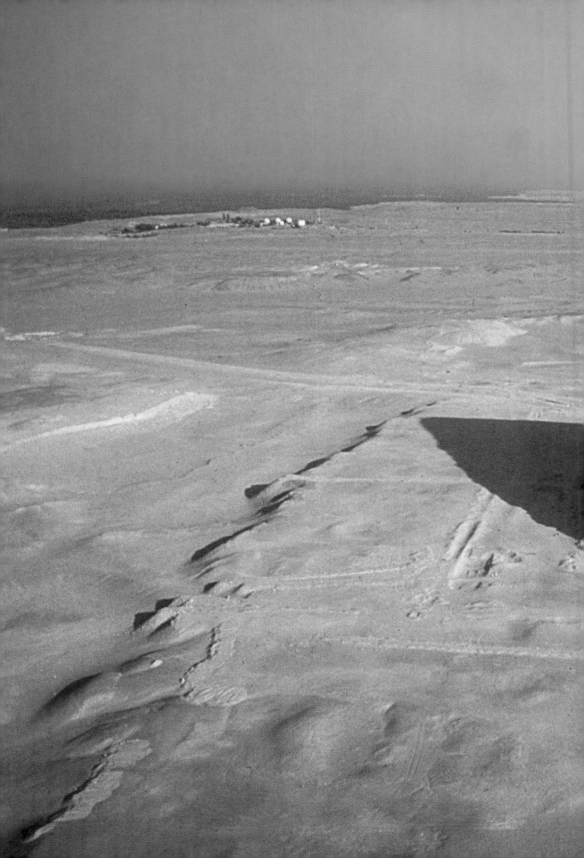

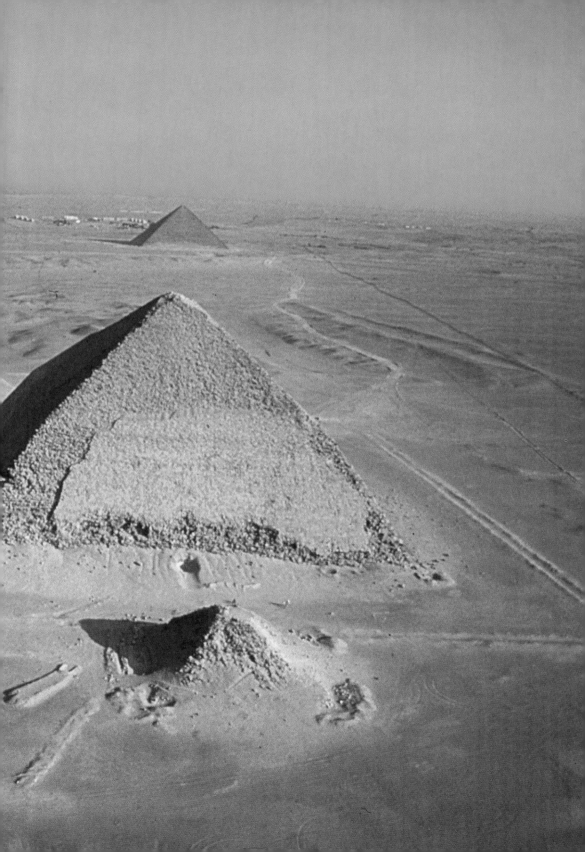

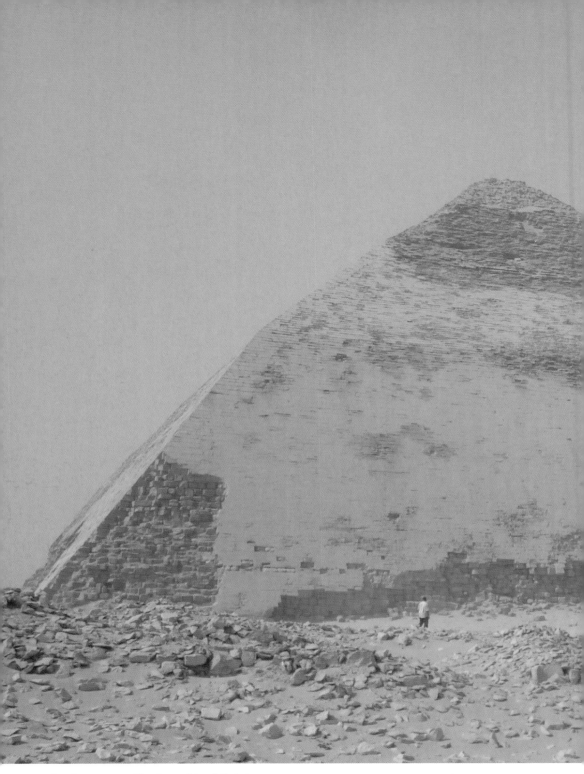

Previous pages: The Pyramids of Dahshur

Above: The Bent Pyramid of Sneferu at Dahshur

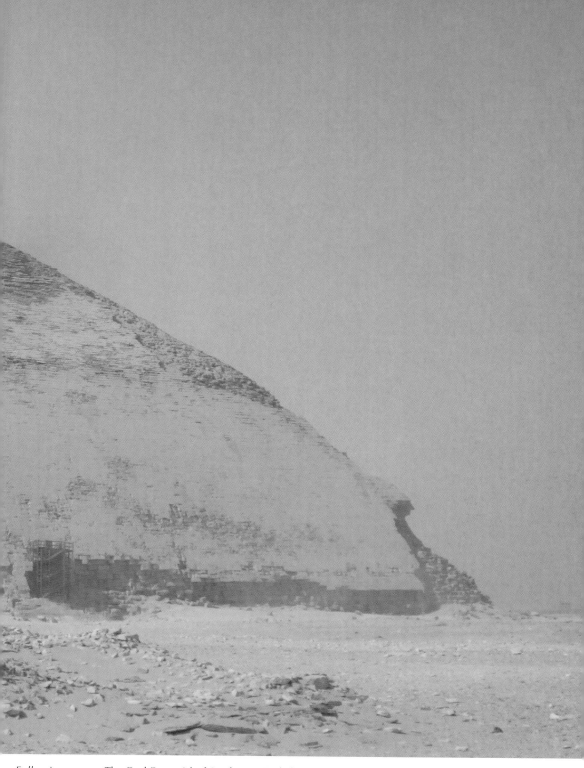

Following pages: The Red Pyramid of Sneferu at Dahshur

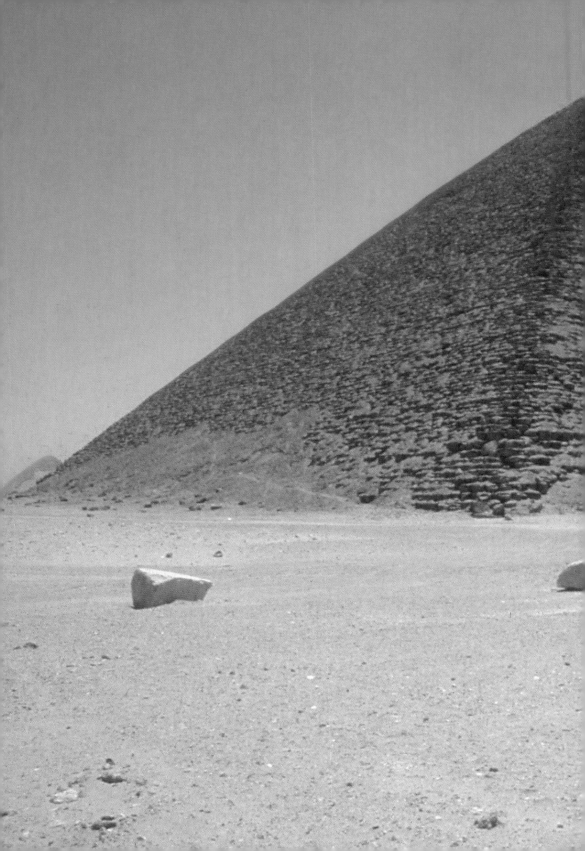

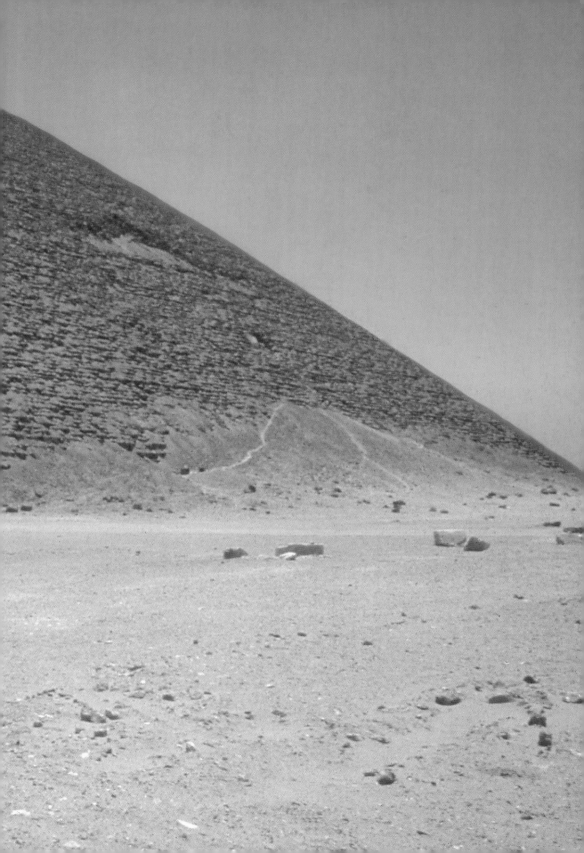

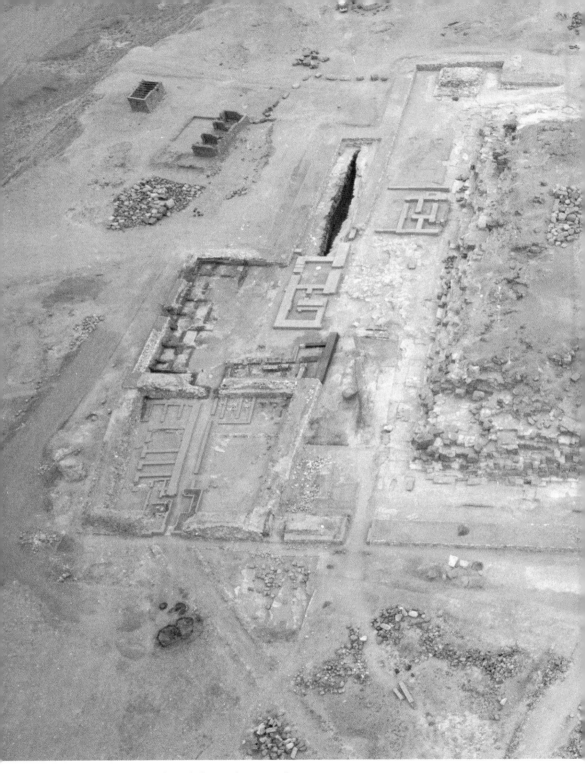

The ruined Pyramid of Djedefre at Abu Rawash

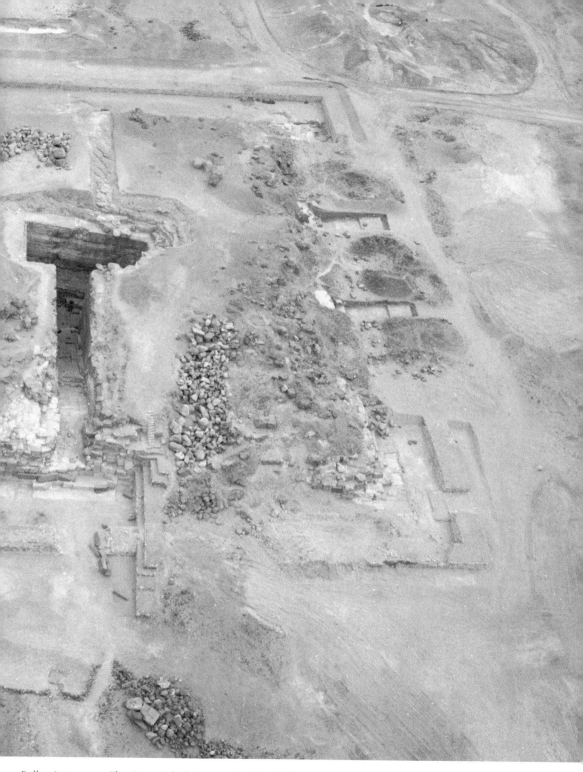

Following pages: The Pyramid of Amenemhat I at Lisht

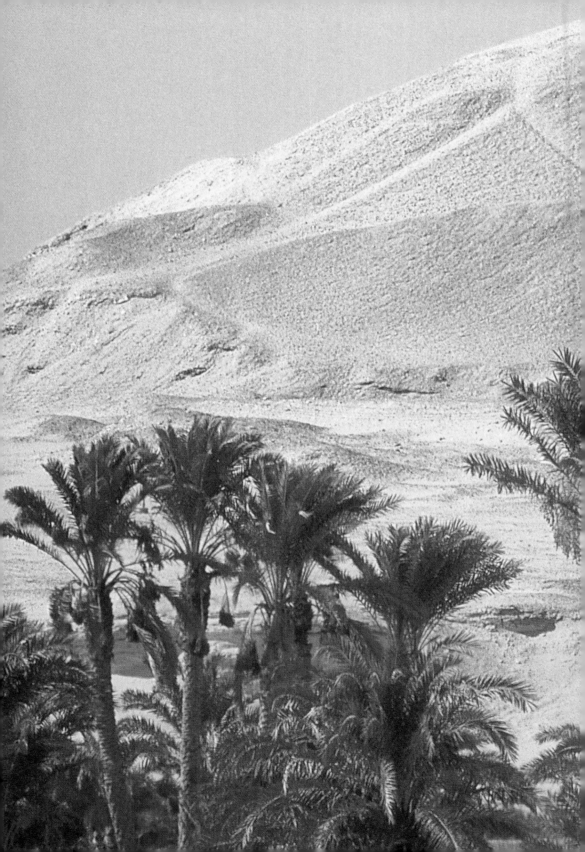

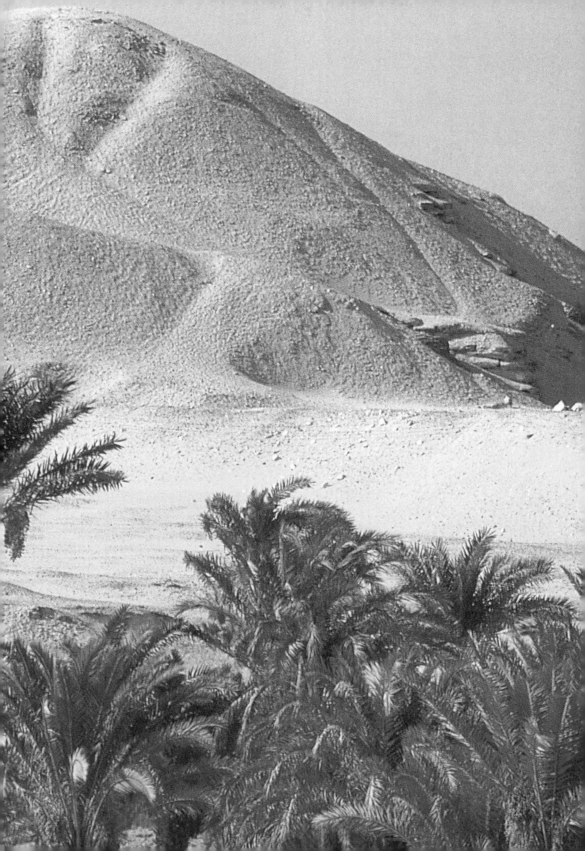

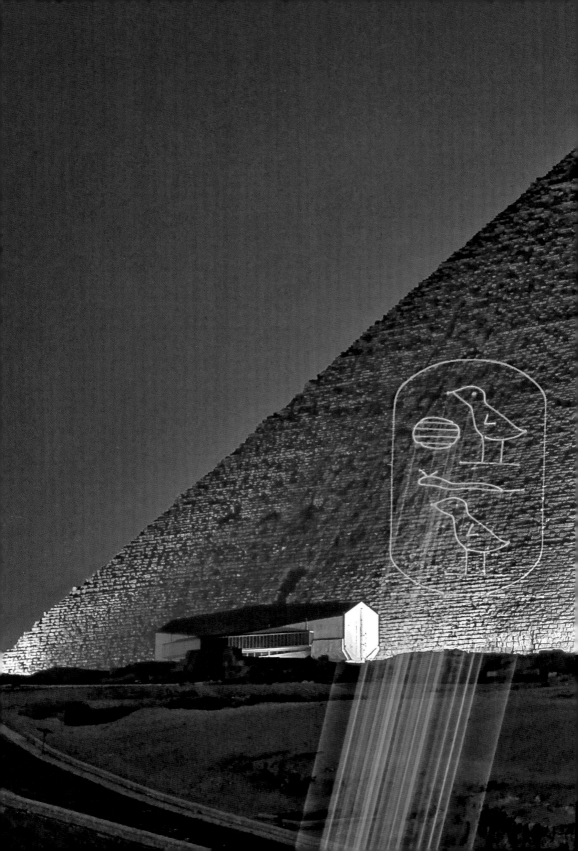

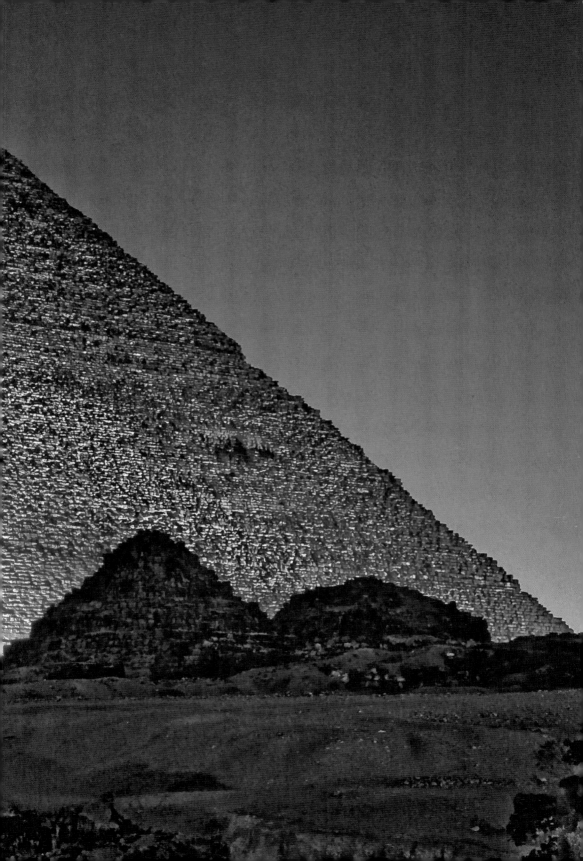

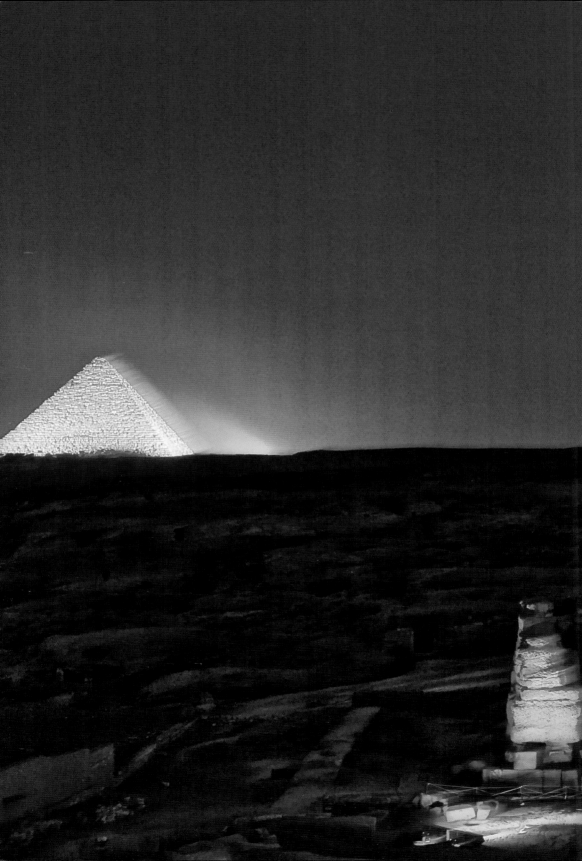

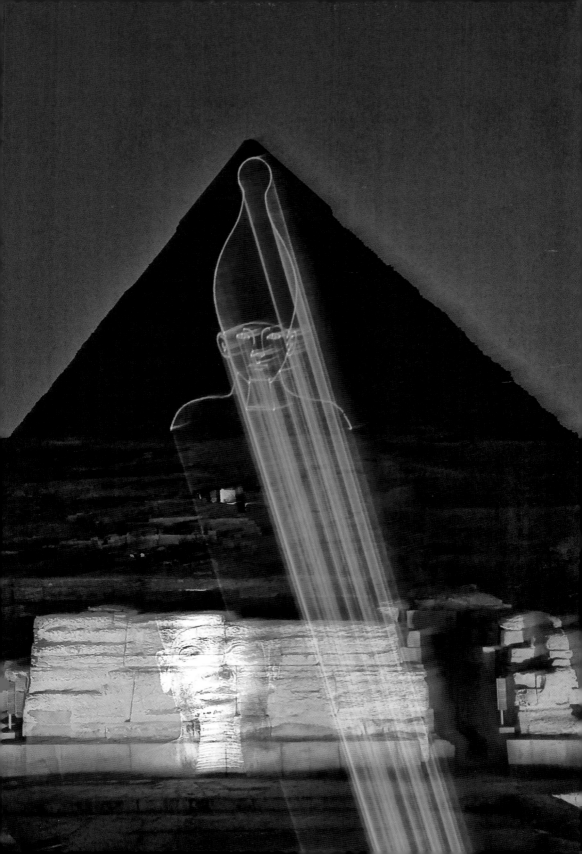

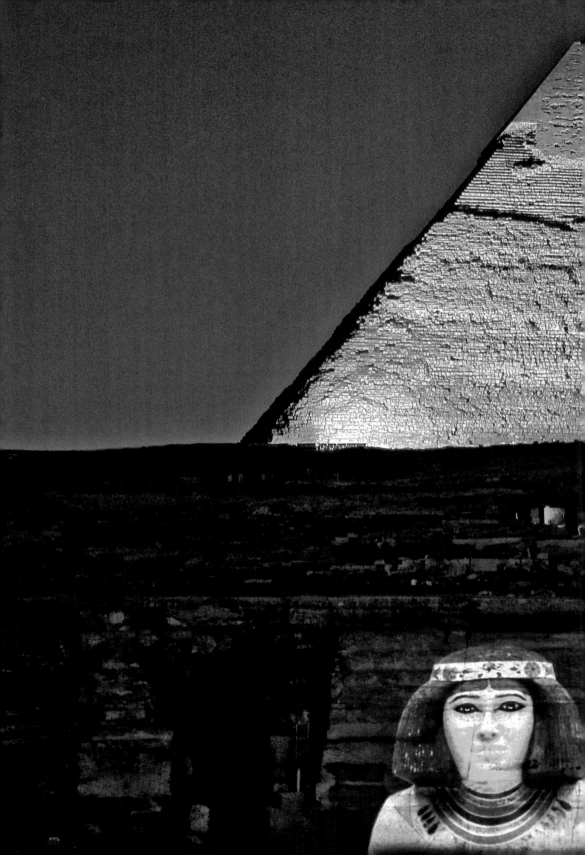

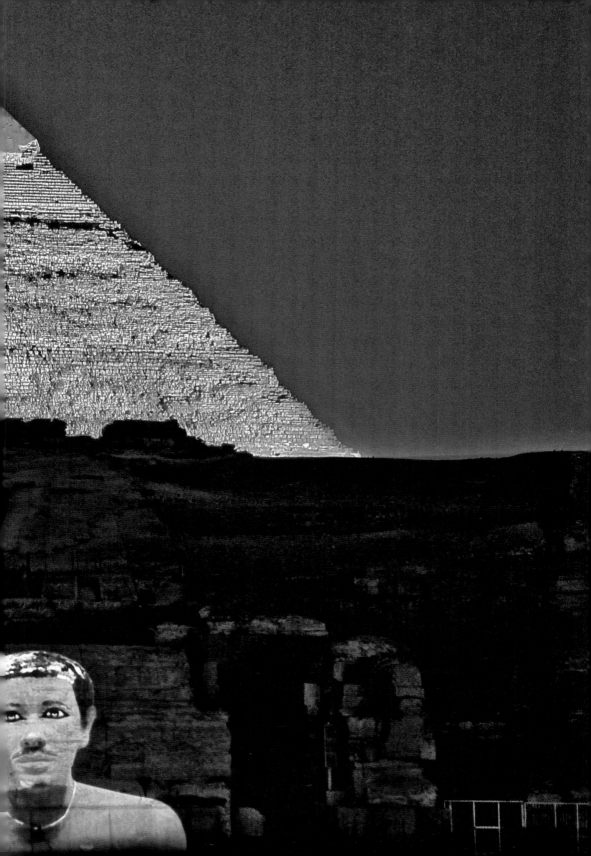

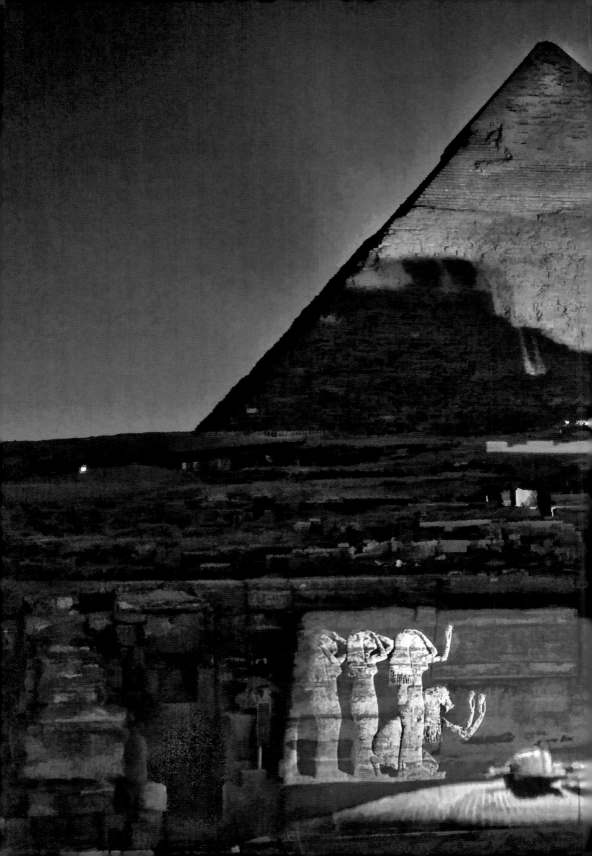

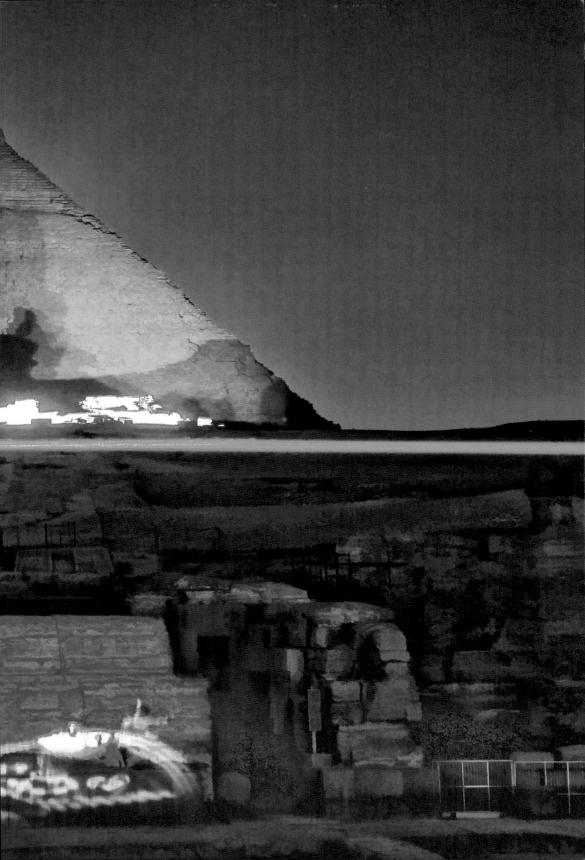

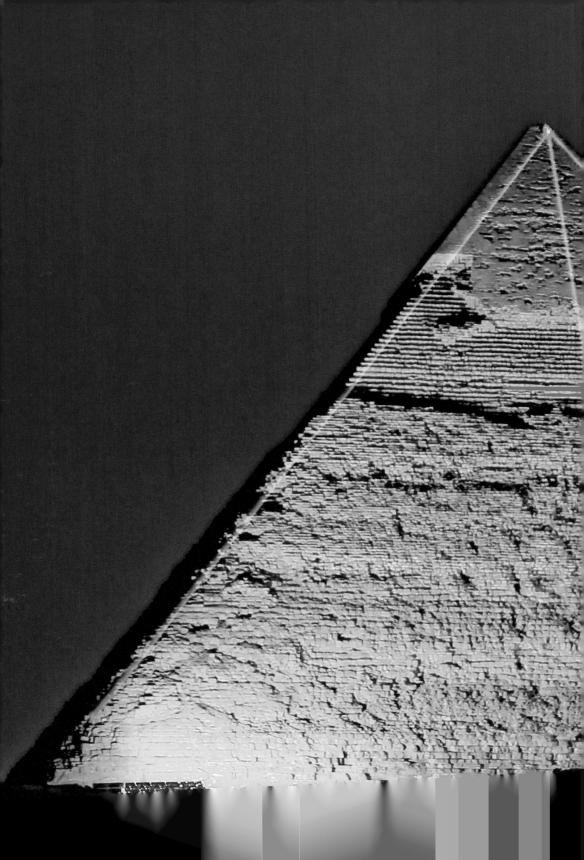

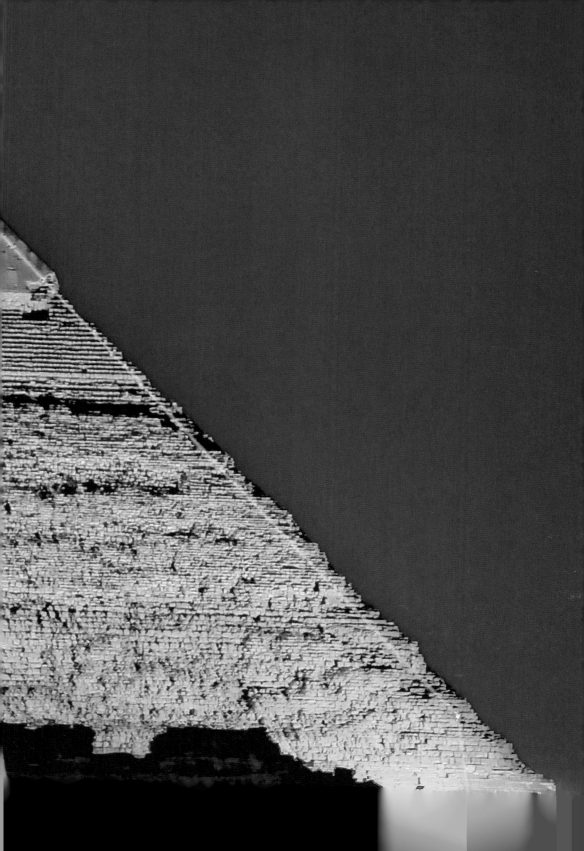

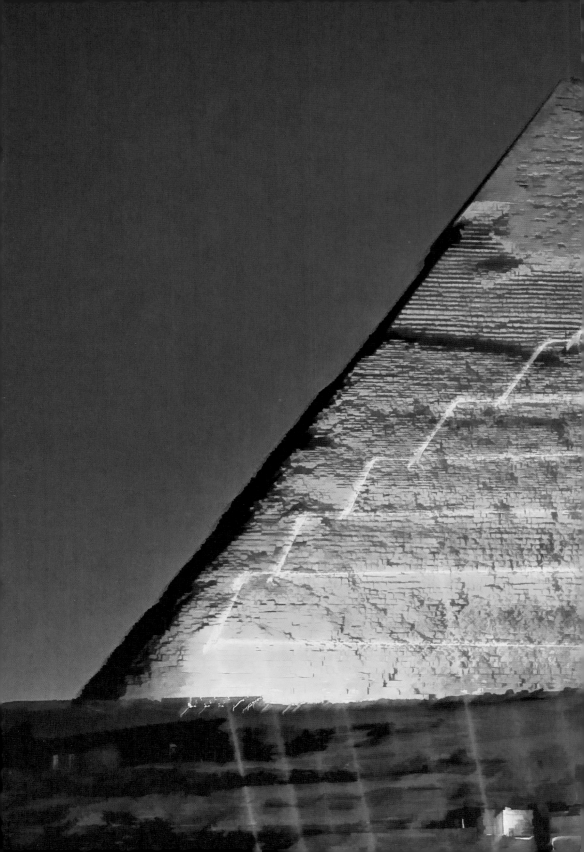

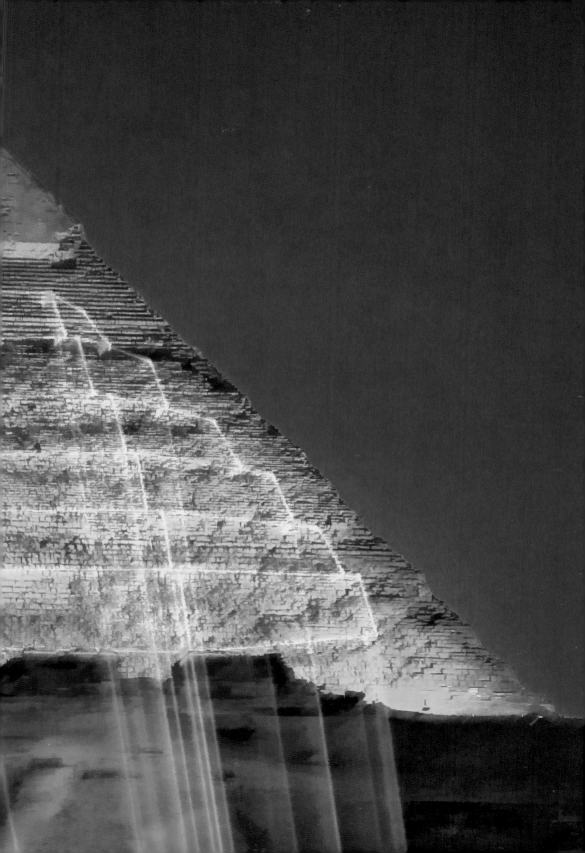

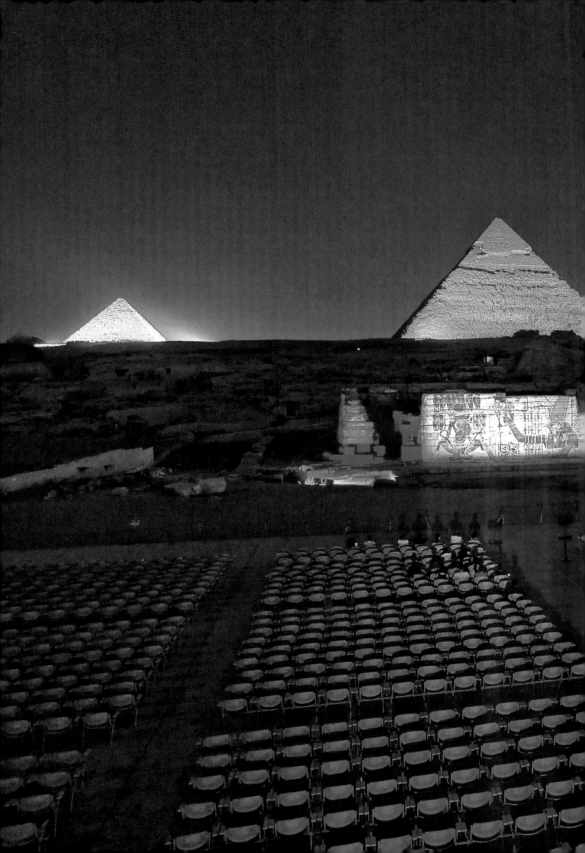

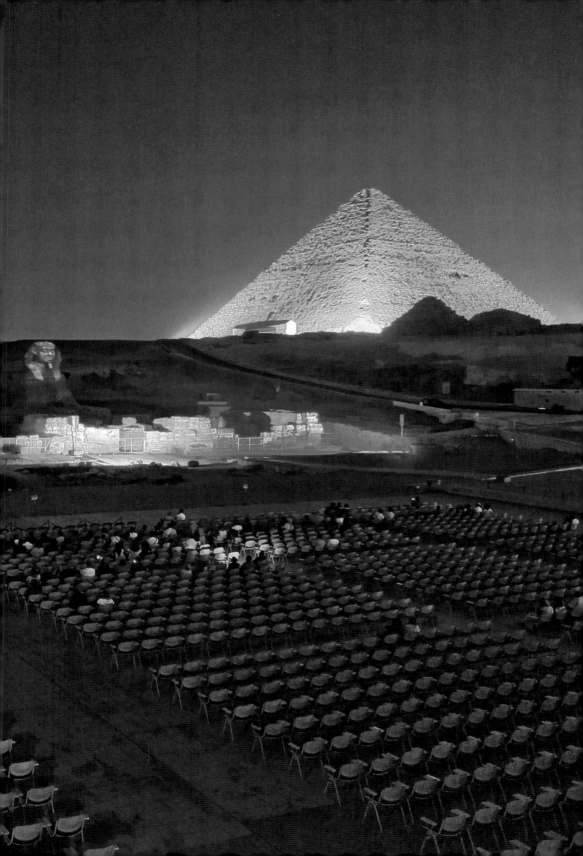

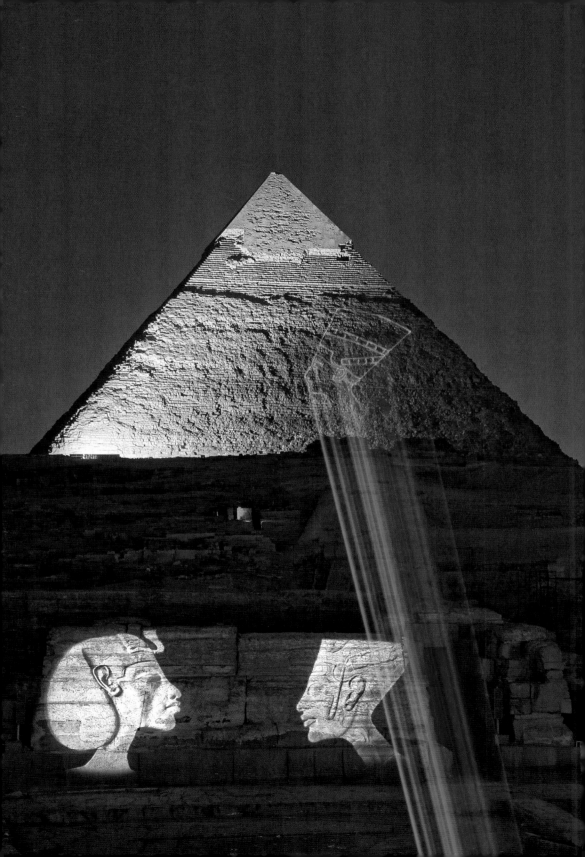

The Pyramids
Sound and Light Show

Narrator 1

You have come tonight to the most fabulous and celebrated place in the world. Here, on the Plateau of Giza, stands forever the mightiest of human achievements.

No traveler—emperor, merchant, or poet—has trodden on these sands and not gasped in awe.

The curtain of night is about to rise and disclose the stage on which the drama of a civilization took place.

Those involved have been present since the dawn of history, pitched stubbornly against sand and wind.

And the voice of the Desert has crossed the centuries.

Sphinx

With each new dawn I see the Sun-god rise on the far bank of the Nile. His first ray is for my face, which is turned towards him. And for five thousand

years I have seen all the suns men can remember come up in the sky. I saw the history of Egypt in its first glow, as tomorrow I shall see the East burning with a new flame.

I am the faithful warden at the foot of his Lord—so faithful, so vigilant, so near him that he gave me his face for my own. I am a Pharaoh's companion and I am he, the Pharaoh.

Through the ages I received many names from the people who came to me in adoration.

Voices

Harmakhis! You are my life's safeguard.

Horus, protect me!

O great God! That I might see you every day!

Lord of the Desert!

Lord of the Heavens!

Sovereign of Eternity!

Sphinx

But the name which has remained with me is that given to me by a Greek traveler: the Father of History, Herodotus. He called me Sphinx, as if I were from his land. And that name is now mine.

Close to the Nile I watch over the plateau of Giza, over all its monuments, of modest or fantastic height. They are tombs.

Narrator 1

Civilizations are like islands on the ocean of barbarism over this one the

Sphinx has gazed and watched for five thousand years.

At the foot of such mountains of stone everything becomes minute and insignificant. Man is an insect!

And yet it was men who built these massive monuments. And the names of Pharaohs, whose tombs they are, have crossed the ages. Their glory has defeated time.

Narrator 2
This is the tomb of Cheops.

Pharaoh of the Fourth Dynasty, four thousand five hundred years ago. Here is the great pyramid which he built to defend himself against death . . .

Narrator 3
Four hundred, fifty-five feet high. He achieved the building of the highest monuments then known to man. The area it covers is vast enough to hold St. Peter's Cathedral in Rome, the cathedrals of Florence and Milan, Westminster Abbey, and St. Paul's.

Three million blocks of stone, some of them weighing thirty tons, were assembled by Cheops' faithful workmen to achieve this fabulous construction.

At the center of it the Pharaoh planned his inner chamber where his mummy was to lie in splendor for eternity.

Narrator 2
At the foot of this Pyramid, in the rock a temple was built and there were kept the barges of Cheops, the barges of night. In these large wooden vessels the dead Pharaoh could continue his voyage in darkness, towards eternity.

But all that remains of him is a small ivory figure showing a noble face: the nose aquiline, the jaw determined, and the hieroglyphs representing the name he gave to his pyramid.

"Cheops dominates the Horizon."

Narrator 2

The Pyramid of Chephren!

It too bears an inscription: "Chephren is great."

Yet out of respect for his father Cheops, Chephren built his pyramid on a slightly smaller scale. Each side of the base measuring 710 feet, the angle being fifty-two degrees, it reaches a height of 445 feet.

The brilliant covering of polished limestone on the apex originally extended over all four sides, adding to the magnificence of the pyramid.

Narrator 3

The face of Chephren has come down to us sculpted in green diorite streaked with white, a rare stone he brought back from an expedition. Here he is, close to us, in the guise of the Sphinx, carved in rock near his tomb.

Narrator 4

Mykerinos!

A third monumental tomb was soon to complete this immense funeral site of Giza and make it one of the wonders of the world. Though smaller, the pyramid of Mykerinos is perhaps the most impressive for being the culminating point of a vast design. Having built it, the workmen climbed down from its granite flanks and laying down their tools, looked up with wonderment.

Narrator 5

Great and powerful was Memphis, the capital city in the plain which joined upper and lower Egypt.

Narrator 4

Great and powerful were the Pharaohs who on this side of the Nile built for eternity.
Its aim accomplished, the Fourth Dynasty collapsed.

But the pyramids still stand.
And the inscription on the one that completed the design claims: "Divine is Mykerinos."

Narrator 2

Here three Pharaohs reign: Cheops, Chephren, and Mykerinos.
Sarcophagi may be empty, wrapping unwound, yet Cheops, Chephren, and Mykerinos still reign, bearing the double crown of Upper and Lower Egypt. They reign over their court buried round them.

Over these small pyramids where their queens lie. Over the tombs of their ministers. Over the whole hierarchy, sleeping forever: chamberlains, high-priests, buffoons, architects, courtesans, each in his proper place in these funerary chambers which are called mastabas. For this is a royal palace of the dead, with triumphal perspectives, pavilions, corridors, secret rooms, strong walls.

It was a city of another world, approachable by the people only as near as the outer temples, where their devotion led them.

Narrator 1

Coming from the Nile, one ascended by a monumental causeway, built on the same colossal scale, to the high temples where only the priests lived among the secrets of the mummies. They alone knew for what journey the

great barges were being prepared at the foot of the tombs. A journey with the sun. A journey which has lasted four thousand, five hundred years! In the maze of this necropolis, let us stand by a tomb like a thousand others, that of the mother of Cheops. And in it, by the litter marked with golden hieroglyphs, which she had prepared for the eternal journey by her son's side.

Neither wind, nor sand, nor centuries could ever entirely silence the Voice of the Desert.

Sphinx

I bear witness of the will of Cheops, my father: to defy time, forever. I saw Anthony and Cleopatra pass. Alexander, Caesar, and Napoleon paused at my feet. I saw the ambitious dreams of conquerors whirling like dead leaves. As my motto, I chose an Arab Saying: "The world fears time, but time fears the Pyramids."

Narrator 1

Of all ancient monuments, it is the pyramids, which have always appealed most vividly to man's imagination. Considered from its top downwards, a pyramid is like the sun's rays bursting through a gap in the clouds. It commemorates the greatest victory of all: victory over death. It is the most perfect mansion, the strongest tent, whose great stone sides are both roof and wall, and so carefully sealed that the dream entrusted to it can live to the end of the world.

The dream of immortality . . . To achieve this embalmers prepared the body for two months, emptying it of all but its heart and kidneys.

Hidden in the secrecy of its tomb, attended by a whole crown of statues, provided with all that was necessary for the journey, there, in the sarcophagus lay the mummy, to be called on by the soul: for alone and without the body the soul could not go into the night.

And from the depth of this tomb still rises the scent of herbs, cedar oil, resin, and myrrh.

But a pyramid is also the perfect combination of simplicity and magnitude, and the interlay of its angles makes the best harmony of shape and volume. It is architecture's purest achievement because it relies on the straight line alone. Never has the straight line been drawn with more mastery, skill, and strength. Homage must be paid to Imhotep the learned, who at Saqqara conceived and built the archetype of pyramids; made up of six mastabas, it rose gradually in a broken line of steps. The idea had been born, calculations had begun, the perfect form was there.

Among all the objects laid by a dead man's side in his tomb, a scribe's palette is undoubtedly the most precious: from it were drawn the hieroglyphs representing the figures which made possible the fabulous calculations ordering these mountains of stone; a lotus flower for a thousand, a finger worth tenfold, a tadpole for a hundred thousand, and the scribes two hands joined in prayer for a million.

Narrator 2

Stone by stone it was built from earth to heaven.

It was built in a Pharaoh's lifetime by one hundred thousand workmen united in a mighty surge of faith. Each stone averaged two and a half tons in weight; three million blocks were hoisted up and laid one upon the other. The finest ones, of pure granite, were dug up in the quarries of Aswan whence they came by boat, carried by the flooding of the Nile. The movement of these great waters drove the farmers from their inundated fields to the plateau of Giza where they joined the army of laborers and built.

These stones were hauled singly on earth-mounds banked higher and higher as the edifice grew.

Narrator 3

In front of such superhuman effort can one believe in the legend of the whip? It needs mystical fervor to build a pyramid! Faith. Those who worked here deserve not our pity but our deepest respect and admiration. They lived through one of those rare times when man knows with absolute certainty what he has to do and where to go. Because he believes. Here, man thought that death was vanquished.

Sphinx

There at my feet, on this vast site, with mankind still in its infancy, walked and worked surveyors, geometers, astronomers to whom no star was unknown, engineers, architects, a whole people, while the rest of the world hunted wild beasts and sheltered in caves.

A Voice

O noble Nile, I salute you, for your waters flow majestically and fostered this sacred enterprise. One day the desert sands invaded the fields, marshes dried up on the river's bank. And so to save his life man invented civilization. He had to contend with floods; he designed dams and culverts. He came to love the earth and want it for his grave. But soon he wished to outlive the earth. And it was farmers, helped once more by their beneficent river, who built these monumental houses of the dead.

Sphinx

And I, Chephren I's faithful companion, saw the progress of dynasties and grave priests and the light steps of noble ladies whose diaphanous veils seemed to clothe them, yet not to touch them.

Legend 1

Do you remember the story of the falcon that stole a sandal while the women where bathing? He snatched it in his beak and by chance dropped it near a Pharaoh who was giving audience in his garden . . . So slender

was the sandal, so small its size, that the Pharaoh wished to see the owner. And he married her.

Legend 2

And do you remember how a nobleman at the court of Cheops lured his wife's lover into a deep lake by means of a wax figure, and there had him turned into a crocodile by a magician? Wishing to impress the Pharaoh with his magical powers, he willingly revealed what he had done, but carelessly too for Cheops punished the guilty and the boaster equally. On his orders, the courtier was thrown to the crocodile which devoured him and the unfaithful woman was chastised.

History 1

Do you remember too a young Pharaoh, Amenhotep II? Never had there been an athlete so strong, so handsome, so fine. His shoulders were broad, his waist slender, his thighs were of bronze and he could tame at will the wildest horse. His exploits are engraved on a stone, which he laid before you!

History 2

Then time in passing left you behind like an old monument. Sand was beginning to choke you. Kept by war in Mesopotamia, Amenhotep II was far away from his land. Then, one day, while hunting the lion, a prince stopped to rest in your shadow. He fell asleep; you gave him a dream and spoke to him.

Sphinx

"Cast your eyes upon me, my son. Listen to me and the white crown and the red will be yours, the crowns of Upper of Lower Egypt. Yours will be the land in its breadth and length. Do you see how I am forlorn, how my body is neglected? I the Master of the plateau of Giza. Deliver me from the sands and you will be king!"

History 2

When he woke up, the young man obeyed, delivered you from the sands, was crowned as king Tuthmosis IV and had engraved between your fore-legs the dream you inspired him with. And then there was great rejoicing.

Commentator 1

The coronation ceremonies have begun. The crowds have gathered on the bank of the Nile to watch the ritual tests of strength. Now the royal barge is coming upriver, manned by two hundred oarsmen . . . Responding to the excitement of the crowd, they increase their pace. The Pharaoh, himself at the tiller, maneuvers perfectly and brings the barge smoothly into the landing-stage with the last burst of speed. Cheers break out as the Pharaoh comes ashore and swiftly makes his way towards the targets of copper set for his display of archery. The crowds follow him to watch.

Commentator 2

Here, while he waits for his bows to be brought, his eye is caught by the bucking of a half-tamed horse and he harnesses it to his chariot. There is a gasp in the crowd, but the Pharaoh is holding the reins tightly and curbing the horse to his will. He drives it round the dais, then brings it quietly back to its groom . . . The crowd cheers.

Commentator 1

Now the Pharaoh has chosen his bow. He has tried more than fifty others before selecting this one. He mounts this chariot and rides off towards the first target. (cries)

The arrow has gone straight into the center! (cries) And again and now . . . (cries) now, his last arrow hits the target and goes right through!

Commentator 2

This is his triumph. Standing up in his chariot, the Pharaoh makes for the dais where his throne awaits him. The court, the priests, the people

present him with praise, incense, and offerings. He receives the double crown and mounting his triumphal chariot, goes to worship in the temples of Harmakhis, Cheops, and Chephren. Long live the Pharaoh! . . .

Narrator 2

A monarch's reign has ended. The Pharaoh is dead, and now, from the valley, rises the sad laments of his funeral.

Narrator 3

A Pharaoh is at rest in his coffin made of wood adorned with gold and precious stones. The ceremony at the lower temple is over and ascending the causeway, the funeral procession nears the tomb, escorted by princes, high state officials, and priests.

The sarcophagus is ready, at the heart of the pyramid, in the funerary chamber, and everything has been prepared for the crossing of the lake, which leads to the gates of the other world.

The last slab of stone is going to be sealed with such cunning that it will never be known which part of the wall was the door.

The high priest gives the final farewell.

Priest

"Now, King, thou leavest us not dead, thou departs alive! If thou goest, thou shalt return soon. If thou sleepest, thou shalt awaken, if thou diest, thou shalt walk again.
Thou who hast risen to the undying stars, thou shalt never disappear."

Mourners

Alas! Alas! Let us lament, let us lament without rest. O glorious traveler into eternity; thou art now captive

Narrator 1

And so through millenniums, dynasty succeeded dynasty. But among all the monarchs of ancient Egypt, none is more appealing than this young Pharaoh, a poet and a mystic, who followed Amenhotep III.

Narrator 3

Civilization is its splendor, had spread southwards step by step, making the valley of the Nile like a triumphal way bordered by the papyri of learning, furrows of prosperity, terraces of peaceful living, and deep meditating tombs. The flame of knowledge had passed from Memphis to Thebes.

Woman's Voices

Large pensive eyes, a weak body, and girlish softness, such is the strange youth who has been made all powerful. He leaves Thebes in order to found his own city. He rejects the God Amun and his priests to worship a God of his own choosing. Aton who is in Heaven. And he discards the name of Amenhotep IV to adopt another, Akhnaton. Aton the Unique . . .

Woman's Voice

With him the walls surrounding the royal wives fall; the veils are drawn back and in centuries to come, people will see and love the graceful figure of Nefertiti.

She was by his side in his struggle to establish the new faith: of this faith she was like a reflection; her radiance inspired sculptors; thus the image of her beauty came to us in stone.

History 1

Thirty years old and he died . . .

Three thousand, three hundred years ago, he wrote and recited this prayer.

To Akhnaton

"Your dawn, O living Aton, takes my breath; you possess my heart. You are the maker and giver of all things and men live by your grace. Aton, living and life giving forever and ever."

Narrator 1

Their love lasted but a season, the time of a bloom called Nefertiti, yet there is sadness still in the hearts of men. His successor's name was to have been Tutankhaten. He chose to be known as Tutankhamen, after the old God of tradition. Frail and tender, Tutankhamen died not yet twenty, after a reign of six years. But three thousand years have not yet withered his fine youthful face nor tarnished the treasures gathered round him in his unfinished tomb of the Valley of the Kings. Today the world marvels at them.

Sphinx

I who know the untouchable stars, know too that the Nile which made Egypt cannot unmake Egypt. I saw conquerors reflect before me and bow their heads. I saw Alexander the Great handsome as a barbarian, thoughtful as a prophet. Here, somewhere in this earth, he rests, awaiting resurrection. I saw Caesar one evening he feared the sun. Our last queen, Cleopatra, bore him a child. But Caesarion was not a true Pharaoh and died before ascending the throne. I saw Napoleon and his burning eyes. Centuries passed over my forehead. Yet those great soldiers raised no more than dust . . .

Sphinx

I have known years of despair. An irascible emir of the Middle Ages disliked my smile, thought it pagan and ironical and so had me disfigured by his artillery. Then children found me ugly. No longer did anyone come and pray at my feet. Or listen to me. The keys of Old Egypt were lost. I was nearly buried in sand. All our knowledge, our very soul rolled in thousands of papyri, was sleeping unknown and unintelligible in dark and silent tombs.

Narrator 2

Yet the miracle did happen. It was in 1799, near Rosetta. One of Napoleon's officers discovered a stone, a monolith bearing an edict issued by Ptolemy: the inscription was in Greek characters and hieroglyphs. This was the cornerstone of Egyptology.

Narrator 3

True, it still remained to interpret its message. First came an Englishman, then a Frenchman, Champollion, the true father of Egyptian philology; he was so inspired as to decipher the last tongue of ancient Egypt from a few mysterious hieroglyphs.

Narrator 4

Then it was like a resurrection!

All at once, from the funerary chambers to the peaks of the pyramids, hieroglyphs were born to a new life. Herons, lotus flowers, fishes, hares, and drakes, the mysterious characters suddenly woke up, fluttered, and sang like creatures of the field as the sun rises.

It is as if in answer to a celestial call of trumpets, Old Egypt had risen from its grave, young and immortal. Young, immortal, and rich in beauty like Nefertiti . . .

Narrator 1

Unearthed from their deep silence, the papyri rustled with a hundred voices. They had bloomed on the bank of the Nile. They had crossed through time. And then five thousand years later they unfolded the dramatic story of a civilization. From their leaves even rises the voice of the first schoolboys who struggled to write, they were weary and feared the cane.

Schoolboy

Master, because you beat me I have learnt my lesson.

Master

Child, no matter how great and deep our knowledge, offer your constant thanks to God.

He will grant you his grace always.

Narrator 1

And learned men from the whole world in quest of this civilization, stronger than sand and death, were enthralled when, in maxims and proverbs, they found a wisdom as ancient as the pyramids, as eternally young. In the depth of the tombs they heard voices rising again after thousands of years.

Voices

The plans of men never wholly succeed, but only what God has ordained.

If you want to keep the friendship of people you visit as master, brother, or friend . . . beware of women! The room where they sit is full of ill feelings.

Do not answer good by evil. Justice comes before strength.

Narrator 1

And historians were deeply moved because so many centuries later they were reading . . . yes, love letters.

Girl 1

What can be sweeter than walking in the fields before a man one loves?

Girl 2

I can no longer touch your heart . . . why?

Girl 3

If I go walking, you are there with me, everywhere. With every step. My hand is in your hand.

Girl 4

Listening to your voice troubles my mind. My whole life hangs on your lips. For me, seeing you is better than eating or drinking.

Sphinx

Such was my message from the depth of the ages. Girls' voices. The voice of wise men, of children. The voices of ancient Egypt. And if those voices sounded familiar to you, it is because their first echo had already reached you through Greece and Rome, Christianity, and Islam.

Sphinx

Tomorrow, once more, the rising sun will give me his first caress. Thousands of other suns shall rise again and man's oldest achievement will remain the highest, the purest.

Voices

The Nile be praised for it is the father of all our harvests, all our knowledge, all our architecture, all our strength!
The Nile be praised! From its banks came one of the seven wonders of the world.

The Nile be praised for it bears tomorrow's prosperity and happiness.

The Nile, river of hope, from Aswan to the Delta.

The Nile, which is not a grave, but a cradle.

Sphinx

In the course of time, only human achievements crumble and fall, but the spirit which conceived these monuments cannot perish!

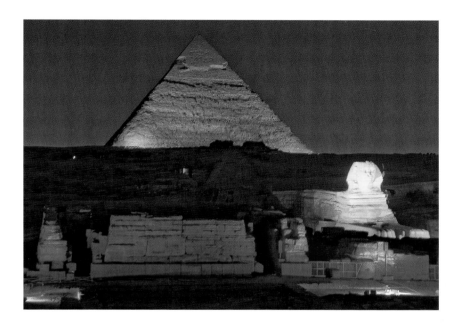

The Creators of the Sound and Light Show at the Pyramids
Script: Gaston Bonheur
Music: Georges Delerue
Artistic direction: Gaston Papeloux

Suggestions for Further Reading

The British Museum Book of Ancient Egypt, edited by A. J. Spencer. British Museum Press, The American University in Cairo Press, 2007.

The Complete Gods and Goddesses of Ancient Egypt, Richard H. Wilkinson. Thames & Hudson, The American University in Cairo Press, 2005.

The Complete Pharaohs: The Reign-by-Reign Record of the Rulers and Dynasties of Ancient Egypt, Peter A. Clayton. The American University in Cairo Press, 2006.

The Complete Pyramids, Mark Lehner. The American University in Cairo Press, 2004.

A History of Egypt: From Earliest Times to the Present, Jason Thompson. Haus Publishing, The American University in Cairo Press, 2008.

Mountains of the Pharaohs: The Untold Story of the Pharaohs, Zahi Hawass. The American University in Cairo Press, 2006.

Pharaonic Civilization: History and Treasures of Ancient Egypt, Giorgio Ferrero. The American University in Cairo Press, 2008.

The Pyramids: The Mystery, Culture, and Science of Egypt's Great Monuments: History and Treasures of Ancient Egypt, Miroslav Verner. The American University in Cairo Press, 2002.

The Treasures of the Pyramids, edited by Zahi Hawass. The American University in Cairo Press, 2003.